PHILADELPHIA BEER

A HEADY HISTORY OF BREWING IN THE CRADLE OF LIBERTY

Rich Wagner

Foreword by Lew Bryson

Charleston — London

THE
History
PRESS

Published by The History Press
Charleston, SC 29403
www.historypress.net

Copyright © 2012 by Rich Wagner
All rights reserved

Front cover image: Interior view of Bergner & Engel's Bottling Department, circa 1887,
Handy Collection.
Back cover images, left to right: Philadelphia Love sign with beer, *Vivienne Dobbs and Jessica
Berzon*; view of Bergner & Engel's racking room, circa 1887, *Handy Collection*; Bob Boileau on
Philadelphia Brewing Company's packaging line, *Rich Wagner*.
Back cover, bottom image: Blob top on bottle from Independent Brewing Company of
Philadelphia, *Cartin Collection*.
Text: Rich Wagner.

First published 2012

Manufactured in the United States

ISBN 978.1.60949.454.4

Library of Congress CIP data applied for.

Contents

Foreword

I don't recall when I first met Rich Wagner, but I do remember when I first saw his handiwork. It was in the men's room at the Valley Forge brewpub, while I was—well, that's not important. I looked up, and around the walls I saw not crude or witty graffiti but a timeline of brewing in Philadelphia. Old British names, old German names—a lot of old German names—and the odd smattering of Irish and Scottish names in there as well, all attached proudly to brewing houses that had regional and national reputations. That's cool, I remember thinking, and seeing the small sign thanking Rich Wagner for the timeline. Rich Wagner? Who's that?

In short order, as I visited more of the newly opening breweries in Philadelphia and the surrounding suburbs, I ran into Rich's name more often. It wasn't just this local area, either; Rich's name cropped up in connection with quasi-legal explorations of closed breweries in New Jersey, Maryland and most of eastern Pennsylvania. Rich was clearly as obsessed with beer and brewing as I was; he just had a focus on the past, rather than the present.

When I finally did meet Rich, I found out more about that focus. He led the brewery explorations, he had an early webpage about brewery history (webpages back in those early days were hard work, too!), he had posters and guidebooks he sold at breweriana conventions and he even had t-shirts with glorious logos of breweries long closed.

But that wasn't all. Rich took it further, in a very physical way. He brewed at the Manayunk Brewing pub for a few years, putting real sweat and toil

into the craft, and he would also don colonial garb—vest, short pants, buckle shoes, tricorn—to brew in ye olde high style on the antique equipment at Pennsbury Manor, the restored home of William Penn. Rich takes his history pretty seriously.

Luckily for him—and us—he lives in an area that's rich with it. Philadelphia's early history as a home to both English and German settlers ensured that the smell of cooking malt would be drifting along the shores of the Delaware and the hills of the Schuylkill. There was plentiful fresh water and a thriving port where early brewers could receive shipments of European malt—a trade that would soon be supplemented and then eclipsed by farmers growing barley in the rich soil of southeastern Pennsylvania.

Brewing was a big part of Philadelphia, as John Adams would find when he came to the city to represent Massachusetts in the Continental Congress. Adams, a typical New Englander, was used to starting his day with a tankard of cider: hard cider, as we say today, but then it was the only kind there was. Once he discovered Philadelphia's brewers, though, he took to them just like we do today. "I drink no cider," he wrote home to his wife, Abigail, "but feast on Philadelphia beer."

The popularity of English ale would shift to German lager in the middle of the next century. Lager beer, the brewing innovation that swept Europe after the isolation of the specific yeast that best loved fermenting cold and clear, came swiftly to America, and it is significant that it came to Philadelphia. Philadelphia was still America's most important city, though New York would soon surpass it, and the city's large German population ensured a market for the lagers that grew out of Bavarian brewing traditions.

The first known lager brewer in America was John Wagner, who brewed on American Street, which would eventually be the site of the much larger and more successful Ortlieb brewery. Wagner was no relation to Rich Wagner, at least not to the best of my knowledge. But Rich's dogged digging was a part of the confirmation of John Wagner's status as America's first known lager brewer, and Rich's continued campaigning was directly responsible for the Pennsylvania Historical Commission marker on American Street noting and honoring the achievement.

Lager brewing exploded in Philadelphia. Between Germans thirsty for the beer gardens of their former home and the exhausted industrial workers of this busy manufacturing center, breweries prospered and expanded. The section of the city across the Schuylkill from the zoo became known as Brewerytown; competing breweries opened across the street from each other, taking advantage of suppliers' routes and plentiful water from the

river and shallow wells. Other neighborhoods supported breweries as well; it was too big an industry to be squeezed into one area.

These were massive, over-engineered buildings in the traditional European style. Even with the advent of mechanical refrigeration, it was still advantageous to have a well-insulated building; the entire fermentation hall would be kept cool, not just individual tanks as is done today. So two- and three-foot-thick walls—brick with concrete or dirt cores—were common, and floors were two feet or more of concrete. That kind of insulation was well known to ice companies and kept the fermenting beer cool even in the hot, muggy Philly summers.

It also kept those buildings intact after Prohibition ripped apart the businesses that built them. After the rise of the national brewers eventually put even the survivors like Ortlieb's out of business, the buildings held on, solid as rocks, and were used as warehouses once the metal guts had been ripped out and sold for scrap. Some of them were beautiful, some of them were stolidly workmanlike and plain at best, but by 1990, none of them was a brewery any longer.

Rich Wagner kept tabs on these old places, pointed them out to the few of us who were interested, knew where the bodies were buried—literally, as the brewers of that gilded age had ornate tombs—and when things turned around, he was ready. Microbrewers saw these old buildings, purpose-built for brewing, and jumped in. Red Bell took up operations in the old Poth Brewery in Brewerytown and Poor Henry's opened up in the old Ortlieb's bottling house (understandably, "poor" Henry was Henry Ortlieb). Although the two of them would fail, Philadelphia Brewing is thriving in the old Weisbrod & Hess Brewery in Kensington and helping to rejuvenate and beautify the neighborhood while they're at it.

Rich made sure everyone knew what they were preserving, and he still gives historical lectures at Philadelphia Brewing. This is a great time for him—and us—a blending of the history and future of brewing. I know people are interested; they constantly contact me with questions about this or that old and long-closed brewery. When they do, I can happily tell them they've got the wrong guy. Happily, because I know where to send them: Rich Wagner. He's answered a lot of questions, and now it's all together in this book. Enjoy it, and respect the long heritage of brewing in this great American city.

Cheers,
Lew Bryson

Preface

For a city with a brewing legacy spanning over three centuries, Philadelphia has a great deal in the way of resources for researchers. These combined with the many books that have been digitized and made available online have been indispensible in piecing together the story of Philadelphia's brewing industry.

The Free Library contains a wealth of information of all kinds. Beyond the vast collection of books, there are city directories, maps, newspapers and periodicals, many of which can be accessed online. These include the *Hexamer General Surveys*, which contain information, exterior views and floor plans of nineteenth-century industrial sites from the region. New surveys were made when breweries completed building programs, making it possible to view the evolution of plant complexes.

Collections of the Historical Society of Pennsylvania, American Philosophical Society and Library Company of Philadelphia also provide invaluable resources that include family papers, business ledgers and other primary sources of information. Many of these date back to Philadelphia's early years.

Temple University's Urban Archives include a vast array of books specific to the city, as well as the *Evening Bulletin*'s morgue, which contains photographs and newspaper clippings arranged by subject.

The Mid-Atlantic Region branch of the National Archives in Philadelphia contains the United States Industrial Census records for a number of years. Information on capital invested, machinery and employees, as well as

quantity and value of raw materials and products, provides insight into the operations of nineteenth-century breweries.

Trade journals such as the *Western Brewer* and *American Brewer* contain many details about technology, architecture, individual breweries, equipment, production, changes in ownership and advertising.

In addition to the writers who long ago chronicled the city's history, there are contemporary scholars who continue to interpret this same history. There are also a host of writers who have reported on the craft brewing renaissance in *Mid-Atlantic Brewing News*, *Ale Street News* and other papers.

People are another tremendous source of information. In addition to librarians and curators, there are those who owned or worked in the city's breweries who shared their knowledge and experiences. Breweriana collectors have preserved much of the city's brewing heritage through their hobby. Labels, trays, signs and advertisements contain information unavailable through other sources. Both the Eastern Coast Breweriana Association and the American Breweriana Association have libraries with materials available to members.

Three books stand out as primary sources of information: Stanley Baron's *Brewed in America* is perhaps the finest scholarly work written on the subject to date; *One Hundred Years of Brewing* was published as a supplement to the *Western Brewer* and covers the United States brewing industry; and Dale Van Wieren's *American Breweries II* lists breweries by state and city, showing changes in ownership and address by year. The last two sources are currently available online to members of the American Breweriana Association.

Acknowledgements

I would like to thank all of the librarians and curators who have aided my search for materials. I'd especially like to thank the entire staff of the Free Library, particularly Richard Boardman in the Map Room, whose knowledge of the city has been most helpful. The Historical Society of Pennsylvania has a wealth of material, and the staff's knowledge of the collections has been invaluable in locating primary source material. The American Philosophical Society is another tremendous resource, and I'd like to thank Roy Goodman in particular for, among other things, introducing me to *Accessible Archives* when it was on a disc, before the days of the internet. I'd also like to thank the staff at the Library Company of Philadelphia, past and present, for their assistance. It was Ken Finkel, as curator of prints, who pointed me toward a great number of resources very early on in my research. Dr. Susan Appel of Illinois State University, who specializes in architecture of Midwest breweries, has been part of my discourse community for many years and has always been willing to share her knowledge and research, particularly with regard to architects.

On the subject of general Philadelphia history: Harry Kyriadodis, Torben Jenks, Alan Johnson and Ken Milano have provided insights on the city's neighborhoods.

I am indebted to the writers who cover or have covered the local craft brewing scene over the years: Lew Bryson, Jack Curtin, George Hummel, Greg Kitsock, Don Russell, Dale Van Wieren and Suzanne Woods. In addition, I would like to thank all of the craft brewers who have revitalized the industry and given the writers something to report on.

Acknowledgements

John Bergmann, John Ehmann, Bill Moeller and Joe Ortlieb are brewers who have shared their recollections and life experiences with me, particularly from the post-Prohibition era. Thanks to Phil Katz of the Beer Institute. I would like to thank the late Pete Bollenbacher, Bill Hipp, Charlie Kraft, Charlie Lieberman and Ray Norbert, who all came from brewing families with long careers in the industry and spoke with me and shared their knowledge. Thanks also to the many descendants of the brewers who have supported this research and offered illustrative materials for this book.

Thanks to breweriana collectors: Tom Ball, Jim Cartin, Don Fink, Larry Handy, Ken Ostrow, Gene Torpey, Tod Von Mechow and Dale Van Wieren have permitted me to photograph items in their collections. We have known one another for years and have shared a great deal of information. John Dikun has graciously provided images from his collection of photographs, and Jim Freeman has shared information from his vast library of brewing history.

I would also like to especially thank my wife, Anna Wagner, for her continuing support, proofreading, editing and suggestions.

Introduction

The first three chapters concentrate on the early days of brewing in Philadelphia. The city had already become a world-class brewing center by the time of the American Revolution. Brewers had been shipping their beer throughout the colonies and the world for nearly a century. As the new nation established itself in all matters of commerce, Philadelphia brewers were renowned for being in the forefront of technological advances and production of superior products. The growth of ale brewing in the city is a mostly forgotten period, overshadowed by the tremendous rise in popularity of lager beer that came with the influx of German immigrants who revolutionized the industry. Once lager began to dominate, there was a decline in the popularity of ale, although it still held a place in the market. It is interesting that what could very well be the nation's first porter, as well as its first lager, was brewed in Northern Liberties.

It has been said that Philadelphia was "one big brewerytown" because there was hardly a neighborhood that didn't have a brewery during the heyday of lager brewing. Chapter Four examines some of the neighborhoods with breweries. Were it possible to include them all, a book the size of a metropolitan phone directory would be required. At its peak in the late nineteenth century, the city was home to nearly a hundred breweries, many producing fewer than five hundred barrels, smaller than most modern brewpubs. In 1909, there were forty-eight breweries in the city, and brewing ranked fourteenth among all industries in terms of the value of its products. Philadelphia had become known as the "Workshop

of the World" for good reason, and the brewing and allied industries were an integral part of that reputation.

The aberration known as Prohibition is addressed in Chapter Five. It lasted from 1920 until 1933. When Prohibition arrived, brewers basically continued with business as usual, not thinking that their product was intoxicating. For brewers from European backgrounds whose families had brewed for generations, it was inconceivable that the product they proudly manufactured should be declared illegal. It was a devastating time for the industry. Brewers tried every trick in the book to stay in business and change the law.

After thirteen long years, Prohibition was repealed, and a handful of breweries came back to life. Chapter Six tells of the survivors who returned after repeal, only to eventually fall, one by one, until there were none. Among the challenges presented to the post-Prohibition brewer were new laws, high taxes and then war rationing. These were especially devastating to the small brewer, and most of those in Philadelphia were miniscule compared to the breweries from the Midwest that dominated the marketplace. Schmidt's became the sole survivor in 1981 and only lasted another six years, leaving the city without a brewery for the first time since 1685.

But there was a grassroots movement underway that would ultimately have a profound influence on the brewing industry as a whole. Microbreweries and brewpubs began to sprout up, first on the West Coast, as with many trends, before finding their way throughout the rest of the country. Chapter Seven chronicles the new breed of brewers that filled the vacuum created by the closing of Schmidt's. The story of craft brewing in Philadelphia has its own tales of woe, but today the city has two production breweries and half a dozen brewpubs. And while that may pale in comparison to what came before, it is as if we have come back to where we started, with today's brewers reclaiming the city's position as a world-class brewing center.

Chapter 1

Brewing in Early Philadelphia

It is difficult to imagine the early days of Philadelphia before there were any buildings or streets. Picture the Delaware River flowing where the Delaware Expressway is today and walking thirty feet down the riverbank from Front Street to its shore. That is where a long-forgotten Water Street was a bustling venue along the wharves. Notches were carved through the bank up and down Front Street, providing public access to the waterfront in the form of cart ways and, later, steps. Dock Street follows the path of Dock Creek, which emptied into the river just above Spruce Street. The Blue Anchor tavern was at the mouth of the creek when William Penn arrived in 1682. There was a drawbridge across the creek to accommodate pedestrians and permit small craft to sail inland.

According to Penn's plan, the city extended from river to river and from South to Vine Streets. Today's Old City encompasses the area where much of the earliest settlement took place between the river and the low numbered streets. According to some estimates, there were five hundred inhabitants and eighty-five houses in Philadelphia by 1683, the same year the first barley crop was harvested.

Beer was a staple of the diet, and in many cases, settlers had to make do with what they could brew themselves. According to Penn, the common beer was brewed with molasses infused with pine or sassafras. Those with means began brewing with malt. In 1685, he extolled the progress being made in Philadelphia by writing that a brewer had established himself and was supplying inhabitants with beer.

William Frampton was a merchant from New York who had been doing business in the Delaware Valley for some time, and he is said to have brought the first cargo of slaves to Philadelphia. In the winter of 1683, he presented Penn with his plans for a brewery and was granted a plot of land at the southwest corner of Front and Walnut Streets along Dock Creek. He built a brewery, a bake house and a brick house that served as a tavern. He had a fifteen-barrel brewing copper, or kettle, with three coolers and other equipment. He died in 1686, but the brewery continued under different owners until 1709.

Two breweries were established in 1685. George Emlen's brewery was upstream from Frampton's, on the north side of Walnut Street between Second and Third Streets. Henry Badcock's Edinburgh Brewhouse was just below Frampton's on the east side of Second Street near Dock Creek. Both men were also tavern owners. Emlen's brewery lasted about five years, while Badcock's had a much longer run.

After Badcock's death in 1734, his daughter, Mary Lisle, inherited the brewery, and another daughter, Elizabeth, got his malt house. Robert Steel purchased the brewery in 1751 and sold all sorts of beer and ale for export in bottles and draught.

Anthony Morris set up a brewery and malt house in 1687 near Frampton's brewery along the waterfront. Malted barley is the primary ingredient for brewing beer. The malting process involves steeping barley in tanks of water, then spreading it out on the floor to germinate. The germination process is stopped at just the right time by drying and roasting the grain in kilns. Barley is the primary grain used by brewers, but other grains, such as rye, oats and corn, can be malted. Malt is also used in distilling. Dark malts are roasted at a higher temperature than pale malts. However, it is pale malt that provides the brewer with more enzymes to convert starches in the grain to fermentable sugar. Darker malts affect the color of beer and contribute nonfermentable sugars, which add body and flavor.

Morris brewed an English-style bitter that developed a reputation for being nutritious and invigorating. In 1706, his son, Anthony Jr., completed a seven-year apprenticeship with Henry Badcock and became a partner in the brewery. When his father died in 1721, Anthony Jr. became sole owner.

Samuel Carpenter was a wealthy merchant who built a wharf on Water Street between Walnut and Chestnut. His brother, Joshua, built the Tun Tavern on the cart way leading to the wharf and, a few years later, built the Sign of the Tun brewery next door. This gave the city five breweries, all within a block or so of one another, each filling the air with the sweet aroma of boiling wort.

A Heady History of Brewing in the Cradle of Liberty

In 1701, Joshua Carpenter built a country estate between Chestnut and Market Streets and between Sixth and Seventh Streets. The estate included a brew house and distillery on Sixth Street. Breweries frequently had stills since beer can be distilled into spirits. Joshua's son, Samuel, ran the brewery on Sixth Street and took over the brewery on the wharf in 1714. He advertised "Strong Beer, Good Ale and Middling Beer" and bottled beer for customers, supplying good bottles and corks. The brewery continued under various owners until 1875.

George Campion had a brewery on the west side of "upper Front Street" from 1721 until 1731. He was a tavern owner and brewed beer for export. He hired James Davis, who had served an indenture with Henry Badcock. Campion ordered Davis to mark thirty barrels of beer headed for South Carolina with an HB brand, which Davis recognized as that of his previous employer. Campion's partner and son-in-law had advised that only beer so branded would sell there. Davis refused and Campion explained that the beer was for the wedding of his granddaughter, Henny Boud. Davis still refused and published a letter in the *American Weekly Mercury* in February 1722 to clear himself from being part of the scheme.

In 1725, John Danby purchased Carpenter's Sign of the Tun brewery on Front Street. It became the Eight Partners Brewery under the direction

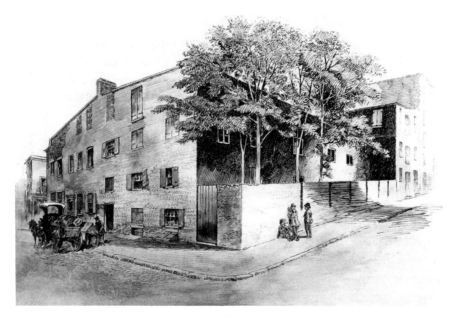

Morris brewery at Dock and Pear Streets, below Walnut. Drawing by Frank H. Taylor, from a photograph by Gutekunst. *Print and Picture Collection, Free Library of Philadelphia.*

19

of Peter Cuff in 1732. His death two years later was lamented by one of the partners who said that Cuff had just brought the business into good order. The brewing season was nearly finished, and the partners decided to keep the brewery running in order to use up the ingredients on hand. Cuff's widow, Elizabeth, took over and hired James Davis as brewer. Products included stout, strong beer and ale, middling beer and small beer. When the lease expired at the end of 1738, the property was advertised for rent.

In 1741, Anthony Morris Jr. gave his son, Anthony Morris III, half interest in his brewery. The elder Morris purchased a house on Second above Arch Street and built a new, larger brewery and malt house on a lot behind the house on Bread Street. He started by constructing a number of underground vaults for storing beer.

Anthony Morris III closed the brewery on the waterfront and purchased a lot at Dock and Pear Streets containing several springs and built a brewery there. The springs provided excellent water for brewing and remained a closely guarded secret.

Matlack's Sign of the Brewers Horse and Dray Brewery

Timothy Matlack established a brewery and malt house around 1746 on the north side of Market between Third and Fourth Streets, which he named the Sign of the Brewers Horse and Dray. A dray is a horse-drawn cart used to deliver barrels. Five years later, he was in financial trouble, and his son-in-law, Reuben Haines, who had an interest in the business, posted a bond. A detailed inventory of the brewery was made to determine the value of all equipment, supplies and product in stock. Combined with the illustration of an eighteenth-century public brew house, it is possible to get some idea of what Matlack's brewery must have looked like and how he brewed beer.

The term "back" refers to a vessel such as a tank, a tub or tun. The term "liquor" refers to water used in brewing. In the following image, above the dome of the copper (C) are the liquor back (LB) and copper back (CB), two square vessels for holding water or liquor, as it is called. The one on the left served as a reservoir for water pumped from a well and the other as a reservoir for hot water pumped from the copper. Matlack had only one sixty-barrel liquor back, which could have served as storage for either hot or cold liquor.

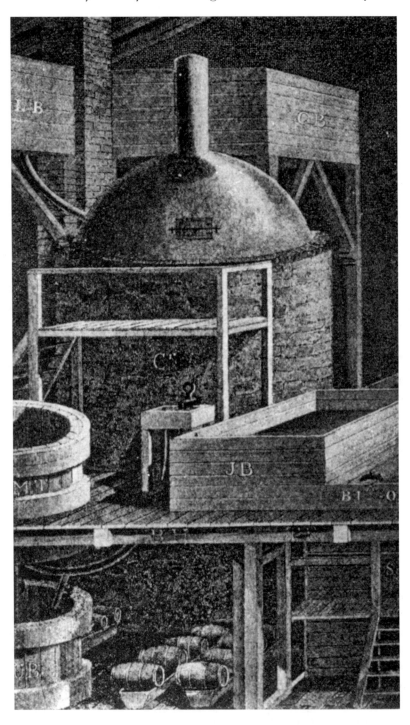

Public brew house, eighteenth century. *From* One Hundred Years of Brewing.

The copper is encased in a brick furnace with a firebox at its base. The brewery had seventy cords of oak and hickory in stock to fuel the furnace. Matlack's copper held twelve and a half barrels and was fitted with a brass cock near the base. During this time period, a British beer keg measured thirty-six imperial gallons. At the beginning of the process, water was drained from the liquor back into the copper for heating.

The mash tun (MT) is shown to the left of the copper. Matlack's mash tun had a capacity of twenty-nine barrels. Malt is milled into grist and placed in the mash tun. Hot water from the copper could be conveyed to the mash tun from the brass cock via a wooden trough. He had two mashing oars for stirring the mash. Mixing is followed by a rest period while enzymes in the grain convert starches to sugar. The resulting sweet liquid is called wort.

The mash tun also serves as a straining device. It has a wooden false bottom with holes drilled in it that rests above the bottom of the mash tun. Wort drains through a cock at the bottom into the under back (UB) below the mash tun. Matlack's under back held fifteen barrels. It was fitted with a wort pump used to transfer the wort back to the copper for boiling. Matlack had three pumps, which could be powered by a horse.

During the boil, hops are added for flavor and bittering. These are the cones or flowers of the hop plant, the essence of which is lupulin, which inhibits the growth of bacteria, thus retarding spoilage of the finished beer. After the wort has boiled for one to two hours, it is drained from the kettle into the hop back (JB, perhaps abbreviated this way because it was sometimes called the "jack back"), which strains the hops. The hops act as a filter for the wort, which then flows into the back (B) or surface cooler. The illustration only shows a small portion of the cooler, the large area of which is sufficient to accommodate all of the wort from the copper in a shallow pool. Steam is given off, and the wort loses its heat to the atmosphere. Matlack's brewery had three coolers of twenty-barrel, twelve-barrel and ten-barrel capacity.

It was common to run hot water through the wort several times, adding a quantity of fresh malt each time. This made it possible to collect three runnings of wort. While the first wort boiled, hot water from the liquor back could be drained into the mash tun where the mashing process was repeated. After the first wort had been boiled and sent to the cooler, the second runnings would be pumped into the copper from the under back. The second and third runnings were generally smaller volumes and less sweet than the first wort. It was common to supplement the third wort with molasses to increase the sugar content.

After the wort cools to body temperature, it is drained into the working tun (WT) or fermenter below. Yeast is "pitched," and the sugar in the wort is converted to alcohol and carbon dioxide during the fermentation process. Each of the runnings would be placed in different fermenters. The first wort would become strong beer, and subsequent runnings would become middling and small beer.

During the first twelve to eighteen hours, a thick head of foam forms at the surface. After several days, the resulting beer is racked into the casks shown beneath the copper in the illustration. Here, fermentation continues more gradually, and the beer conditions in the cellar until it is ready for sale. Generally, the small beer was ready in a fairly short time, while the strongest beer conditioned for an extended period.

Items from the inventory not shown in the illustration included a mill for grinding malt. This was powered by a horse that was hitched to the mill and walked around in circles to turn the grindstone. There was a stock of new and used barrels, tubs and funnels for handling yeast and many other implements. There were also two stills, one 120-gallon and one 28-gallon. Reuben Haines and his son became the proprietors after Matlack's death. They petitioned the creditors for an additional three-year grace period in order to clear the debt.

More Breweries in Colonial Philadelphia

In 1762, Joseph Clark established the New Stone Brew House on Sixth between Market and Arch Streets. He advertised "beer of all kinds, for exportation or home consumption, delivered to any part of the town in any quantity, at the common prices." Isaac Howell took over in 1765 and advertised "choice bottled beer, six penny and small beer for family and ships use." He also sold beer for others to bottle.

Edward Croston and Samuel Spencer Skinner established a brew house and still house at Wharton's Wharf near the Swede's Church in 1760. In August of the following year, they advertised that they had implemented new distilling methods from England and were manufacturing five hogsheads of rum from molasses each day at a quarter of the cost of traditional methods, enabling them to sell full-proof rum at a very competitive price. A hogshead held around a barrel and a half. Merchants could supply them with molasses, and they would distill it or receive rum in exchange. They also made eighty

barrels of beer per brewing using imported malt. Their beer had good reports from the markets to the south that the beer arrived in warmer climates in excellent condition and sold well. They also sold yeast to bakers and families. Edward Croston died two year later, and the establishment was auctioned for a five-year lease.

Valentine Standley and Septimus Levering built a large new brewery at Second and what is now Fairmount Avenue in 1763. They had a store at Fourth and Market where they sold both "single and double" bottled beer. In 1771, the partnership was dissolved, and the brewery became known as the Northern Liberties Brewery, which advertised "good sixpenny beer." It was known as Standley's Brew House until 1781.

In 1762, London brewer Michael Combrune was the first to use a thermometer for measuring the temperature of water for mashing. Until then, brewers had a variety of methods for determining when the water was hot enough to strike the mash. Generally, the water had to be hot enough to "bite your finger smartly" or as hot as you could stand without raising a blister.

The first hydrometer was introduced in 1769. This instrument measured the density of wort, enabling brewers to ascertain how much sugar had been extracted during the mashing process. These two instruments took much of the mystery out of the art of brewing and helped brewers use their materials more efficiently, although many old-timers initially resisted using technological innovations.

Joseph Potts Ale Brewery was established in 1774 at Fifth and Minor Streets, just below Market Street. It is said the brewery was taken over and used as a barracks by the British during the occupation of the city from 1777 to 1778. Henry Pfeiffer became proprietor in 1786. He anglicized his name, and the firm became known as Henry Pepper & Sons. It is best remembered as Robert Smith's brewery, which continued operating at that location until 1888.

Robert Hare was the son of a porter brewer in Limehouse, England, who came to Philadelphia with £1,500 from his father. In 1774, he formed a partnership with J. Warren, also of London, and started a porter brewery on Callowhill and New Market Streets, between Front and Second Streets, in the Northern Liberties. Porter is a dark beer so-named for its popularity with porters in London. There are a number of interpretations as to its origins, but it evolved from English brown ales, and it is closely related to stout. It became very popular in London, and by 1780, a dozen large porter breweries produced over 75 percent of the beer sold there. Some credit Hare with being the first to brew this style in the colonies. As early as

October 31, 1774, the *Boston Evening Post* advertised that the first shipment of Philadelphia porter had just arrived. While he is not mentioned by name, it is quite possible that it was Hare's porter that was described as being "little if any inferior" to that of London.

Nearly thirty breweries started up from 1685 to 1775. Of the seven breweries that started in the seventeenth century, the Morris brewery at Dock and Pear Streets continued under a variety of owners for 155 years, before closing in 1842. Henry Badcock's brewery spanned 66 years, and Joshua Carpenter's Sign of the Tun Brewery lasted for 48 years.

At least twenty-two breweries started up during the eighteenth century in the years leading up to the Revolutionary War. The brewery that Joshua Carpenter built on his estate lasted for 174 years and was known as Gray's Brewery for about half that span of time. Potts Ale Brewery became Robert Smith's and lasted for 146 years. Robert Hare's Brewery became Gaul's Brewery and, in modern times, was best known as John F. Betz's Brewery, giving it a lifespan of 165 years. The Morris Brewery at Second and Bread Streets remained in business under a variety of owners for nearly a century. At the time of the Revolutionary War, there were at least six breweries operating in the city. This does not take into account home-brewing or unlicensed brewing that may have been taking place.

Brewing in the New Nation

In the last quarter of the eighteenth century, fifteen more breweries went into business. During the Constitution Day celebration in September 1787 commemorating the signing of the Declaration of Independence and Pennsylvania's ratification of the proposed Constitution of the United States, there was a parade that included ten brewers led by Reuben Haines. They had stalks of barley in their hats and carried poles with hops, malt shovels and mashing oars. Luke Morris carried a standard decorated with the brewers' arms with the motto "Home brewed is best." The sentiment resonated with President Washington's "Buy American" policy, and beer and cider, rather than spirits, were served during the festival.

The production of beer and porter in Philadelphia doubled the following year, despite the fact that a great deal of malt liquor was being imported from England. In order to raise money and spur domestic industry, Congress established tariffs on imported goods. In

1793, the United States commissioner of internal revenue reported that Philadelphia was shipping more beer than the rest of the nation's seaports combined. Philadelphia beer was shipped to all domestic and international seaports. A sample of the beer reportedly made a trip to China and returned without ill effects. Around this time, Philadelphia brewers consumed forty thousand bushels of malt per year. The supply of locally grown barley was insufficient, and brewers imported barley from the Chesapeake region and malt from New England.

Chapter 2

Growth of Ale Breweries

In his article "The Industrial Revolution in Brewing," Peter Mathias chronicles many of the technological advances in brewing. He states that by the end of the eighteenth century, grinding and pumping in breweries had been mechanized. Prior to the turn of the century, fans were directed at surface coolers to reduce the time it took for wort to cool. Shortly thereafter, someone patented a system with cold water pipes in coolers to further accelerate the cooling process. Isaac W. Morris introduced a mashing machine for stirring the mash in his brewery on Front Street around 1805. It was locally manufactured and considered to be a success until it broke down, and the cost to repair was prohibitive. This deterred others from adapting the innovation.

The Perot and Morris Families

The stories of many of the city's brewing families are inextricably intertwined, much like the Morris and Perot families. Francis Perot was born in Philadelphia in 1796 and, by the age of fifteen, was working in the countinghouse of his father's business. One day, he passed William Dawson's brewery on Chestnut Street and became fascinated by what he saw there. The proprietor noticed his interest and gave him a tour of the brewery. Francis told his father that he wanted to become a brewer. His father set up a six-year apprenticeship for his son with Thomas Morris at his brewery at

Second and Bread Streets. Francis spent the first two years in the malt house, one year as a miller and one year in the cellar, before being put in charge of brewing. At the end of his apprenticeship, he operated Samuel Downing's malt house in Downingtown for one year and returned to Philadelphia in 1818. He purchased Snowden and Fisher's brewery and malt house on the south side of Vine between Third and Fourth Streets.

A year later, his brother, William S. Perot, joined the firm. They installed one of the nation's first stationary steam engines, which remained in continuous operation for over half a century. The diary of Ludwig Gall describes his travels in Pennsylvania during this period and includes a description of his visit to Perot's brewery. Gall was quite impressed that a steam engine did "all the work, almost without human help of turning grain, hops and water into two hundred barrels of beer and ale a day." He noted the steam engine powered devices in the malt house that hoisted grain, wetted, turned, aerated and dried it. In the brew house, the engine provided motive power for grinding, stirring, pumping and graining out, as well as sawing firewood. Gall exclaimed, "Think of all those devices kept moving together day and night unceasingly, think of the five people that suffice to direct many and diverse operations—think of it all and you will have only a hazy notion of the impressive spectacle that comes from seeing such a plant that works as if by an invisible hand."

A brewer's daybook from the brewery provides detailed descriptions of the brewing operations. The brewing season typically lasted from September until the beginning of May. The season followed the barley harvest, but just as important was the fact that, in order for wort to cool properly, the surrounding air had to be sufficiently cold. On average, they brewed three days per week and produced around forty barrels a day, depending on the style of beer they were making. Malted barley, malted wheat and sometimes corn were used in the recipes. Hops were not listed by variety but were described as being "mild" or "long keeping" and were frequently boiled twice. They brewed strong, middling and small draught beer, as well as porter, ale and summer beer or summer ale. Some beer was shipped to Virginia and Georgia, but most was sold locally.

Francis Perot married Elizabeth Morris, daughter of his former employer, in 1823. In 1850, Perot went into the malting business exclusively. His son, T. Morris Perot, teamed up with his father and brother-in-law in 1869 to form Francis Perot's Sons.

Francis Perot's marriage to a descendant of Anthony Morris gave legitimacy to the company's claim to be the "Oldest Business House in America," having been incorporated in 1687. The company had another malt house at Twenty-first and Spruce Streets, and in 1882, it purchased a

malt house on the Erie Canal in Oswego, New York, providing access to the Canadian barley fields. In 1887, the firm was incorporated as the Francis Perot's Sons Malting Company, and the business continued into the 1960s.

The Morris brewery at Dock and Pear Streets was run by Luke Morris from 1790 until 1799. Donald F. Johnson's thesis, entitled "Making and Marketing Beer in the Delaware Valley, 1760–1800," uncovered a great deal of detailed information on Luke's brewing practices. One of these practices was an innovation known as step infusion mashing, which improved efficiency. Using this technique, brewers extracted more sugar from the malt. Luke's records from a brewing in October 1786 show he mashed in with twelve barrels of water at 165 degrees Fahrenheit. After a rest, he added seven more at 185 degrees. Following another rest, he added ten barrels at 175 degrees. Finally, he added six barrels at 190 degrees, resulting in twenty-six barrels of wort to the copper. His hydrometer readings were expressed in ounces. Yeast was pitched when the wort had cooled to between 50 and 70 degrees. In a letter to a Baltimore bottler, Morris said he shipped him hogsheads of old and new porter mixed, a style popular with the local trade. The brewery went through a variety of incarnations, but the common thread was William Abbott. He partnered with James Abbott from 1815 to 1833 and was the last owner when the brewery closed in 1842.

At the Bread Street brewery, Thomas Morris admitted his sons, Thomas Jr. and Joseph, into the firm in 1813, and the family continued in business there until 1834 when James Abbott and Robert Newlin took over. Newlin had a variety of partners over the years, including Wilson Abbott. In 1853, he advertised that additions had been made to the brewery and that the cellars had a capacity to hold twenty thousand barrels. Abbot's ale and porter were distributed throughout the nation.

Gray's Brewery

The brewery on Sixth Street just south of Market that had been built on Joshua Carpenter's country estate back in 1701 changed hands several times. William Gray purchased the lot and built a new brewery around 1772. He continued the business until 1784. The brewery remained idle from 1789 until Robert E. Gray and James Kennedy started it back up in 1807. It became known as Gray's Brewery, and Samuel N. Gray became a partner from 1812 to 1840. George Gray joined the firm in 1840 and was connected to the business until

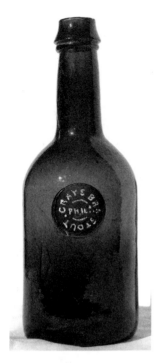

1866. *Twitt's 1857 Directory of Prominent Businessmen* listed them as "heavy manufacturers, dealers and shippers of Brown Stout, Porter and Ale" and advertised their products as being unsurpassed.

Gaul's Brewery

Frederick Gaul came from Frankfort-on-the-Main prior to the Revolution. In 1804, he was in partnership with Casper Morris operating the Haines brewery on Market Street. In 1812, he leased it from the younger Reuben Haines, and it became known as Gaul's Brewery. As early as 1822, Gaul installed a mashing machine for stirring the malt in one of his two mash tuns.

In 1824, the firm purchased the old Hare brewery on Callowhill and operated it as plant number two. Gaul also owned a malt house in Kensington. In 1843, Gaul closed the brewery on Market and moved all operations to his

This Gray's Brown Stout bottle, circa 1825–30, is the oldest known embossed beer bottle from the United States. *Von Mechow Collection.*

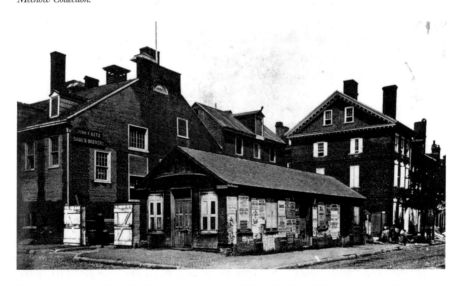

Gaul Brewery faces New Market Street just above Callowhill. John F. Betz purchased the brewery in 1869. A market building is seen to the right of the brewery. *Philadelphia Archives.*

second plant on Callowhill. With the addition of steam power, production in 1860 amounted to twenty-four thousand barrels. Products included Gaul's Pale Ale XX, porter, ale and beer.

Rudman's Eagle Brewery

In 1828, William C. Rudman became proprietor of a twenty-year-old plant on the north side of Green Street above Third. It became known as Rudman's Eagle Brewery, with a production of around three thousand barrels. By 1845, sales were up to eight thousand barrels. Four years later, expansions to the plant brought production up to eighteen thousand barrels. An advertisement in the *Sunday Dispatch* in May 1852 stated that Rudman had just completed a series of vaults with a capacity of holding twenty-five thousand barrels, believed to be the most extensive in the country. The brewery changed hands a number of times and closed in 1879.

Massey's Brewery

In 1822, a stock company of farmers from Delaware and Chester Counties financed a brewery at the northwest corner of Tenth and Filbert Streets with the purpose of having a guaranteed market for their barley and a source of spent grain to feed their cattle. The company failed, and it was sold to the Philadelphia Brewers' Association. One of its members was William Dawson, the man who inspired Francis Perot with a tour of his brewery on Chestnut Street. Dawson and his partner purchased the brewery. In 1849, the brewery was acquired by Poultney, Collins and Massey, becoming William Massey & Company in 1869. It was incorporated as the William Massey Brewing Company in 1882 and remained in business until 1894.

William Massey was the son of a brewer in England and came to Philadelphia as a young man in 1828. He worked in Gray's Brewery for two years and then moved to New Orleans and got into the bottling business. In 1844, he started bottling beer for Dawson & Company and five years later moved to Philadelphia to become an owner of the brewery.

In 1850, Massey was producing twenty thousand barrels of ale and porter worth $100,000. His malt house produced 100,000 bushels of malt per

season. Five years later, the plant was greatly enlarged, increasing production capability to thirty-five thousand barrels. Massey's cellars were capable of holding ten thousand barrels and steam-powered pumps brought beer up to the first floor, where it was racked into kegs.

At the Centennial Exhibition in 1876, Massey submitted both draught and bottled porter, which was judged to have good color, excellent taste and fine aroma. The bottled product was commended for its excellence. In both the present-use ale and American stock ale categories, Massey's ale was commended on all counts and judged to be especially brilliant. The brewery won a bronze medal for ale at the Paris Exhibition in 1878. That year, the brewery produced over 58,500 barrels and was the second-largest brewer in the city. Massey's beer was sold up and down the coast from Maine to Louisiana and to the West Indies and South America. The brewery was famous for its pale and amber ales, porter, brown stout and XX Ale.

Taylor's Brewery

Richard M. Taylor started a brewery at the northeast corner of Eighth and Vine Streets in 1830. William Bankston Taylor headed the firm in 1848.

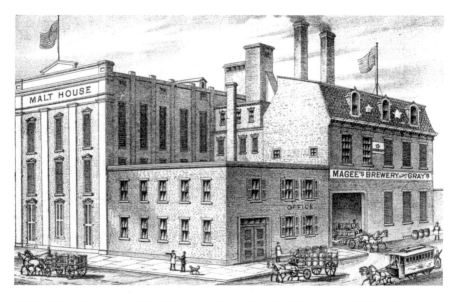

MaGee's Star Brewery and Malt House on the north side of Vine, below Eighth Street, *Western Brewer*, 1881.

Production was around ten thousand barrels, valued at $5 per barrel. In 1865, it became Robert Gray's Star Brewery. In 1870, production was twelve thousand barrels of ale and eight thousand barrels of porter, worth a total of $200,000. Richard Magee became proprietor in 1875. He increased production from sixteen thousand barrels to over thirty thousand barrels by the end of the decade.

Robert Smith

Robert Smith was born in London in 1802 and came to America when he was about twelve years old. As a young man, he served an apprenticeship at the Bass Brewery in England. In 1832, he started a brewery on what is now American and Noble Streets below Spring Garden in Northern Liberties. Four years later, he became a partner at the old Pepper brewery on Fifth Street, below Market. The firm was called Pepper, Smith and Seckel. Advertisements for its brown stout, porter, pale and Amber XX ales said products were constantly on hand of first quality, suitable for home consumption or export and were warranted to keep in any climate. Smith became sole proprietor in 1849.

Dithmar and Butz

Frederick L. Dithmar established a brewery in Northern Liberties on the west side of Third Street above Poplar in 1835. George Butz became a partner in 1843. In 1860, production was around ten thousand barrels of porter and ale. Dithmar and Butz were two of the earliest brewers in Brewerytown, having a second brewery at Thirty-third and Pennsylvania Avenue from 1860 to 1865. In 1866, the brewery changed hands, and two years later, George Carey purchased the brewery and was connected with the business until 1892.

Moore's Ale and Porter Brewery

In 1836, James L. Moore started an ale and porter brewery and malt house in South Philadelphia, on what is now Fitzwater Street above Thirteenth.

In 1850, production was eight hundred barrels each of ale and porter. Ten years later, production was five thousand barrels of beer ale and porter. The brewery went out of business in the early 1880s.

Chapter 3
Lager Beer

P art of the art and mystery of brewing that was most mysterious was the role that yeast played in the process. As early as 1787, Lavoisier showed that fermentation was a process by which sugar was split up into alcohol and carbonic acid, which he defined as being a purely chemical reaction. In 1837, Caignard de Latour linked yeast to fermentation, stating that only healthy yeasts could initiate it. Noting they lacked chlorophyll, he classified them as fungi. Theodor Schwann independently offered convincing proofs of the theory. These conclusions were not accepted by chemists, who held that fermentation was a simple chemical reaction. The issue was resolved in 1857 when Louis Pasteur proved that yeast was indeed living and responsible for fermentation.

The two strains of yeast used in brewing are ale yeast and lager yeast. English ales are brewed with a variety that is active at the top of fermenting beer, and lager beer is made with yeasts that are active at the bottom of the fermenter. The ales brewed in the old days were fermented at cellar temperatures. Most "present use" ale and small beer were sold soon after fermentation and did not contain much carbonation. Lager beer was fermented at colder temperatures and then stored in a cave or icehouse to ripen or age for several months. In German, the word "lager" refers to a storehouse. It was common to kraeusen the beer through the addition of a small amount of new or fermenting beer. This produced a secondary fermentation that naturally carbonated the beer as it aged.

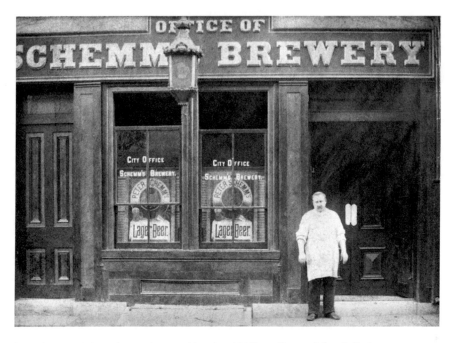

Peter Schemm's lager beer saloon and hotel at 238 Race Street. *Dikun Collection.*

America's First Lager Beer

There is a great deal of debate around when, where and by whom lager beer was first brewed in the New World. But it is generally recognized that the lager beer strain of yeast made its way to America sometime in the 1840s, and more often than not, the credit is given to John Wagner, a brewer from Bavaria, who came to Philadelphia and set up a small home brewery behind his sister's house in Northern Liberties on St. John near Poplar Street. St. John Street is now called American Street, and there is a historic marker there, just above Poplar, commemorating the location where "America's first lager" was brewed.

Charles C. Wolf, of the Engel and Wolf Brewing Company, the company that claimed to be the first to brew lager beer on a large scale in America, described Wagner's brewery as having an eight-barrel kettle suspended by a crane over an open hearth. There was a cellar beneath, where the beer could be fermented and stored. His brother-in-law could not resist temptation and took a jar of the yeast. He was convicted and served two years in the state penitentiary for the offense.

Pioneer Lager Beer Brewers

Engel and Wolf

Mr. Wolf had a sugar refinery at Crown and Vine Streets. In 1844, Charles Engel, a boyhood friend from the old country and a practical brewer, brewed lager beer in his sugar pan. Sugar hogsheads were used to store the beer, which was served to employees and friends who came to call. Soon afterward, Engel and Wolf established a lager beer brewery and distillery on Dillwyn Street above Third. In 1845, they dug vaults for lagering the beer. Mr. Wolf said the local German population loved his beer so much that they frequently drank the brewery dry, and he had to post a sign with the date that the next batch would be ready. The brewery, which was powered by horse and man, produced around seven thousand barrels a year by the end of the decade.

In 1849, they purchased a property at Fountain Green along the banks of the Schuylkill River that contained springs. There they dug seven vaults, five of which were fifty thousand cubic feet in size and extended two hundred feet into the bank, forty-five feet below ground. Mr. Wolf described how they would brew on Dillwyn Street and take the wort by ox cart to the vaults, where it was fermented and aged. Ice was harvested from the river and packed in the vaults to lager the beer over the winter. They built a brewery complex and, in 1859, moved brewing operations there. The brewery was powered by steam and had two direct-fire kettles, one ninety- and one fifty-barrel. Production started out at ten thousand barrels.

The value of lager had just surpassed that of ale by $60,000, and there were thirty lager beer brewers with a capital investment of $1,200,000 in the city. Edwin Freedley, in his book *Philadelphia and its Manufacturers*, described Engel and Wolf's vaults as being carved out of solid rock and partitioned by brick into twenty- by forty-foot cellars connected by doors large enough to admit a puncheon or cask capable of holding two barrels of beer. When the brewing season began after cool weather arrived, casks would be taken to the very back of the vaults. Three rows of the large puncheons would be arranged with an aisle between them. Two rows of barrels were placed above the puncheons, with smaller casks above. When the back cellar was full, the door would be closed and insulated with nonconductors such as straw and tan, the tree bark left over after being used in the tanning process. Workers would fill each subsequent cellar, working toward the entrance until the vaults were full.

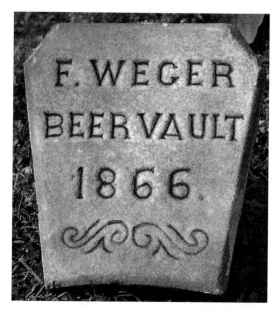

Keystone from Frank Weger's lager beer vault. *Gentile Collection.*

Freedley also described how kegs were lined with resin, which imparted a "pitchy" flavor to the beer, owing to the fact it was derived from pine sap. The head would be removed from the keg and melted resin dropped in and set on fire. After a few minutes, the head was put back in, which put out the fire, and the keg was rolled around so that resin would coat the entire surface of the inside of the keg. In addition to keeping the kegs watertight, the pitch provided a nonporous cleanable surface. Lager beer kegs were under considerably more pressure than those containing ale and had to be especially tight.

By 1870, production was twenty-two thousand barrels worth $175,000. The firm had an agency in New Orleans that served the South, including Texas. That year, the city began enlarging Fairmount Park. In order to improve water quality for the Fairmount waterworks downstream, all industry was removed from that stretch of the river, and Engel and Wolf's brewery property was acquired through eminent domain. Mr. Wolf retired from the business, and Charles Engel joined Gustavus Bergner in Brewerytown, just downstream and away from the river bank. They formed the Bergner & Engel Brewing Company. Mr. Wolf's son, Otto C. Wolf, was among the first graduating class from the University of Pennsylvania's mechanical engineering program in 1876 and would go on to become the city's preeminent brewery architect.

"Der Dicke Georg" or Big George Manger

George Manger was a practical brewer who also worked in Mr. Wolf's sugar refinery. He was given some lager beer yeast and started a small brewery

on New Street above Second around 1844. He partnered with Charles Psotta for a few years and then with Peter Schemm. Schemm had come from a long line of brewers in Bavaria and worked at the Dithmar and Butz brewery when he first arrived in Philadelphia. There was a saloon attached to the brewery that, in 1852, advertised that there was Swiss and Limburg cheese and Dutch herrings, among other goods, constantly on hand for the wholesale and retail trades.

Louis Bergdoll

Probably the best known of the city's pioneer lager brewers was Louis Bergdoll. He learned the brewing trade in Heidelberg and came to Philadelphia in 1846, where he worked for Engel and Wolf, Manger and Henry Mueller. He formed a partnership with Peter Schemm in 1849, and they had a brewery near Fifth and Vine Streets where they brewed around $4,000 worth of lager beer. A year later, he partnered with his brother-in-law, Charles Psotta, and in 1853, they purchased a property near the Falls of the Schuylkill, which had been Governor Mifflin's home. They converted a large barn into a brew house and dug vaults on the hillside fronting toward Mifflin Hollow.

A National Beverage

John P. Arnold's *History of the Brewing Industry and Brewing Science in America* discusses the popularization of lager beer following its introduction to a primarily German American market. He states that the country produced nearly four million barrels of beer in 1860, and of that, about a quarter was lager beer. This was not the case in Philadelphia. Whether due to its large German population or its position as a major city and port, lager beer production had just surpassed that of ale. *Boyd's Philadelphia Directory* for 1858 listed 543 porterhouses with a notation to see also billiard saloons, bowling saloons, lager beer saloons, restaurants and hotels. The following year, the directory listed 577 lager beer saloons. Census figures show that during this decade, the city's population increased from just over 120,000 to over 500,000 residents.

Arnold notes that the popularity of lager beer accelerated during the period of the Civil War. During this period, the use of adjuncts such as corn

and rice was introduced and, by the last three decades of the nineteenth century, was widely accepted among American brewers. Corn was abundant, and the barley grown in North America had enough diastatic potential to convert starch in other grains to sugar during the mashing process. Some German American brewers may have staunchly held to the Reinheitsgebot, the German purity law of 1516, which mandated that beer could be made only with water, malt, hops and yeast, but they were not bound to it by law. In addition, American lager beer was a new style that was lighter, made for American tastes. By using adjuncts, brewers increased their profits.

A movement toward Prohibition had replaced one calling for temperance, and one reaction to that was advocating beer as the preferred beverage. Consumption of distilled spirits went down, and lager beer became popular with a much wider audience.

The second half of the century saw a great deal of scientific progress and technological innovation. By 1870, improvements in icehouse construction and wort cooling techniques had made it possible for brewers to brew year-round. In 1876, Pasteur published his paper "Studies on Beer," which explained how to control the fermentation process. Four years later, Emil Christian Hansen fermented beer with yeast cultured from a single cell. Enzinger patented a process for filtering beer in 1878. Casper Pfaudler introduced his "F.F. Vacuum Process" in 1884. He patented sealed, glass-lined fermenting tanks. Wort was aerated with sterilized air, and carbon dioxide produced during fermentation was evacuated through a valve at the top of the tank. Ice-making machines and the subsequent development of refrigerating machines revolutionized the industry.

Icehouses could be refrigerated with natural or manufactured ice. The *Western Brewer*, 1882.

In July 1879, the *Western Brewer* reported that Philadelphia had a total of ninety-four breweries, thirty-eight of which produced fewer than 1,000 barrels. Only sixteen produced over 10,000 barrels a year. That year, the sale of malt liquors in Philadelphia was nearly 646,000 barrels, second only to New York City, which sold 2,000,000 barrels.

The Centennial Exhibition of 1876

The United States Brewers Association financed the construction of Brewers' Hall, an annex to Agricultural Hall, at the Centennial Exhibition and held its annual meeting there in June 1876. Over the main entrance was a large statue of King Gambrinus, legendary inventor of lager beer. Inside, there were displays of every type of brewing equipment imaginable. Charles Stoll of New York City set up the "Centennial Brewery," with a working 150-barrel brew house. Opposite the brewery were two malt kilns displayed by William Hughes and Theodore Bergner, brewery engineers from Philadelphia. One was of their own patented design. Equipment for cleaning and separating, steeping and germinating barley, as well as malt milling machinery, was all on display.

In contrast to Stoll's modern brewery, there was a model of a brewery showing the state of the art at the time of the Revolution. There was also an exhibit on William Penn's brew house at his country estate, Pennsbury Manor.

There were over 207 exhibitors with everything from raw materials to steam engines, refrigerating equipment, pumps, sheet metal and copper implements, elevator buckets, wort cooling equipment and all manner of tanks, vats and barrels. While exhibitors came from all over the United States and Europe, manufacturers in Philadelphia supplied a wide range of goods and machinery for the trade. Awards were given for barley, malt and hops, as well as equipment and advertising.

On the north side of Brewers' Hall, there was an icehouse. It was double-walled, the space between being filled with shavings. It was divided into three separate rooms: a cool one for ale, a very cold room for lager beer and a third that served as a tasting room. All the beer sent to be judged was kept in the icehouse. Awards were given for draught and bottled beer of all styles.

Chapter 4

Neighborhoods of Breweries

Brewerytown

It is quite common to find sections or districts in cities where specific industries are concentrated, but Philadelphia is unique in having a neighborhood called Brewerytown. Located in the northwestern part of the city above the bank of the Schuylkill River, the neighborhood developed due to the proximity to natural ice on the river. In addition, there were streams and ponds in the neighborhood. It was also a fairly undeveloped section that offered room for growth. Some of the earliest development in the neighborhood involved the construction of underground cellars or icehouses to store lager beer. The first of these was probably constructed for Charles Bergner in the late 1840s. His vault was located at the northeast corner of Thirty-second and Thompson Street and held one thousand barrels. Charles was succeeded by his son, Gustavus, who built a brewery there in 1857.

Jacob and Peter Baltz had a brewery in Northern Liberties, and they constructed vaults next to Bergner in 1852. They added a brewery four years later. Christian Schnitzel established a brewery on Thirty-first below Master Street in 1854. Around this time, Fisher's malt house was built on Pennsylvania Avenue above Thirty-second Street. In 1859, three more breweries belonging to Frank Eisele, Fred Nentzel and Lewis Talmon were in business. Talmon also had a distillery. The following year, Dithmar and Butz, the ale brewers from Northern Liberties, had a brewery next to Fisher's malt house.

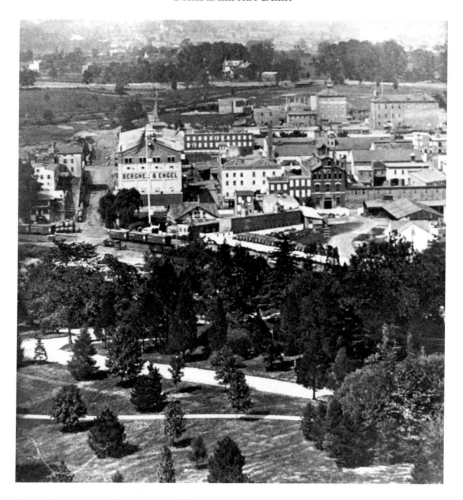

View of Brewerytown from Lemon Hill Observatory around the time of the Centennial Exhibition. Photograph by James Cremer. *Fairmount Park Historic Resource Archives.*

The earliest detailed views are four *Hexamer General Surveys* made in 1866 that cover the area from Thirtieth and Thirty-third Streets, between Thompson and Master Streets and one section of Thirty-first above Master Street. There are fifteen breweries identified. Most had dwellings, and four had saloons. There were at least eight vaults, many located below dwellings or storerooms. There was also a hotel and a wine and liquor store in the neighborhood.

Of the brewers shown in 1866, only four survived into the twentieth century: Henry Rothacker; Jacob and Peter Baltz; Gustavus Bergner; and Charles Theis and Frank Weger. The rest were either absorbed as those four expanded or purchased by others who moved into the neighborhood. A

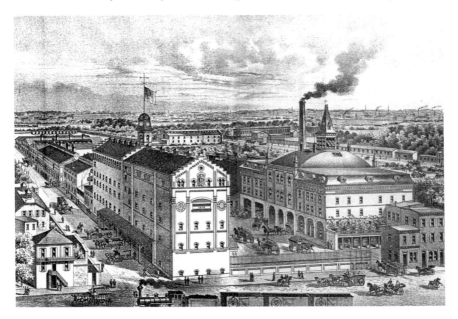

Bergner & Engel's newly completed brewery complex, *Western Brewer*, 1881.

section dominated by breweries would grow to encompass the area between Girard Avenue and Oxford and Glenwood Streets and from Thirtieth to Thirty-third Streets. Within those boundaries, there were eleven breweries, a keg factory, a bottling machinery manufacturer and a feed company that dried brewers' grains. The neighborhood was served by both the Pennsylvania and the Philadelphia and Reading Railroads.

Beyond this concentration of breweries, there were four more to the south of Girard Avenue and one more on Girard across the river next to the Philadelphia Zoo. The neighborhood that became known as Brewerytown encompassed a much larger area and attracted a large German population. Breweries directly employed hundreds of men, and breweries required products and services from a host of allied industries. There were constant improvements and alterations to plants that created construction jobs. Equipment needed to be manufactured and installed. Raw materials had to be delivered, handled and stored. Delivery systems involved wagons, teams, teamsters and people who managed the stables. The neighborhood would be responsible for about half the beer produced in the city by the turn of the century. One newspaperman of the day said the rich aroma of malted grain hung like a fog, making the very air as nutritious as vaporized bread.

Bergner & Engel

Charles W. Bergner came to America in 1849 as the chief creditor of a bankrupt brewery on Seventh Street below Girard Avenue. Production was around two thousand barrels a year. He died three years later, and his nineteen-year-old son, Gustavus, took over. He built a new brewery next to the vault in Brewerytown in 1857, and all operations were moved there, with a production of around twelve thousand barrels. He had a saloon and depot below the post office on Dock Street. Next to the brewery, there was a two-story icehouse with a fermenting room made of stone above the original vault. By 1870, the year Charles Engel became his partner, production had doubled. The brew house had three steam-fired kettles: 150, 100 and 17 barrels.

Bergner & Engel won two medals for its draught and bottled beer at the Centennial Exhibition. In 1878, it took the grand prize in the lager beer category at the Paris Exposition, an accomplishment that did not go unnoticed by the German brewers they were competing against. That year, it produced nearly 125,000 barrels. George Ehret in New York was

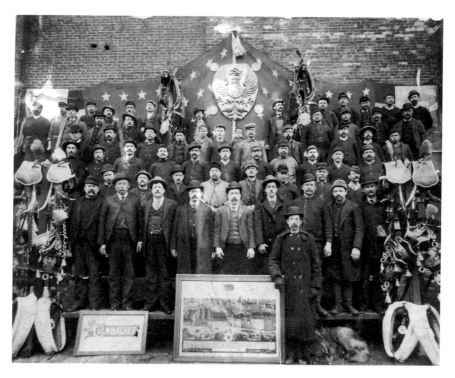

Officers and workers of Bergner & Engel Brewing Company. *Ostrow Collection.*

the largest brewer in the country, with a production of nearly 160,000 barrels. Bergner & Engel was the third-largest brewing firm in the nation. However, the second-largest producer, Philip Best of Milwaukee, had two plants, which meant that Bergner & Engel actually had the second-largest brewery in the nation.

In 1880, the firm embarked on an ambitious building program to double its capacity. Bergner's brother, Theodore, was the architect and engineer. He designed many innovations for the new plant. The old brewery was razed in April, and everything was in place to move in when the new plant was completed in August. Two adjacent breweries brewed Bergner & Engel's beer in the interim. In 1884, a fifty-thousand-barrel ale brewery was added.

Bergner & Engel distributed beer throughout the nation and the world. In addition to its awards at the exhibitions in Philadelphia and Paris, Bergner & Engel won the Grand Gold Medal and Diploma of Honor in Brussels in 1888 and in Paris in 1889, four medals at the Columbian World's Fair in Chicago in 1893 and grand prize at the Amsterdam Exposition in 1895. Its Tannhaeuser Export was pronounced "the finest light beer ever made" in the *Medical News*. Its Culmbacher, a rich, creamy, dark beer, was assessed by many to be equal to the best Bavarian brews. Otto Wolf executed over twenty projects for expansion and improvements for Bergner & Engel in as many years.

J&P Baltz

In 1851, Jacob and Peter Baltz began brewing in Northern Liberties on Third below Buttonwood Street at a place called Military Hall, where they produced around 1,500 barrels a year. In 1856, they built a brewery in Brewerytown and, by 1860, were producing 12,000 barrels of lager beer. They added a large malt house in 1863, and refrigeration was added in 1885.

The brewery added a bottling department in 1886, and in 1891, a Pfaudler vacuum fermentation plant was installed. Otto Wolf executed seventeen projects over the years, including a new brewery in 1890 and a new 150,000-bushel malt house in 1897. At the turn of the century, Baltz had a capacity to brew 125,000 barrels. In 1910, it produced 186,000 barrels, and in 1919, a new bottling house was completed and outfitted with modern equipment. Brands included Baltz Beer and Czar Beer.

G.F. Rothacker and Sons, Lion Brewery

Henry Rothacker purchased Christian Schnitzel's brewery in 1864. He retired four years later, and his brother, George F. Rothacker, became proprietor. Rothacker acquired the Talmon brewery and distillery properties. He admitted his sons, Frank and George, into the firm in 1880 when the company became known as G.F. Rothacker and Sons, Lion Brewery, and was producing nearly seven thousand barrels a year. Its best year was 1907, when it made thirty-four thousand barrels. Brands included Extra Brand, Asmanshaeuser and Pure Malt Beer. Bergner & Engel purchased the property in 1913 and operated it as plant number four until 1917.

Charles Theis Brewery

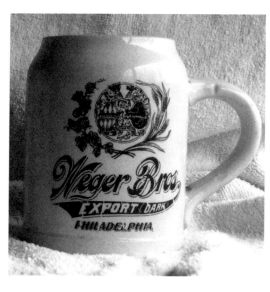

Ball Collection.

Charles Theis was born into a brewing family in Germany. He learned the tanning trade and came to America as a young man, finding work as a tanner and stonecutter. He became connected with the Bauman Whiskey Company and went into the saloon business. In 1846, he established a brewery and lager beer saloon on what is now American above Callowhill Street.

In 1869, his sons-in-law, Frank Weger, brewery foreman, and Louis J. Ladner, became partners in the firm, which then became known as Charles Theis and Company. The company established a brewery on Thirty-second between Thompson and Master Streets and ran the adjacent malt house on Pennsylvania Avenue. Output was around fifteen thousand barrels.

Ladner's family ran a large opera saloon on Third below Spring Garden, and in 1872, Theis established an office and bottling works in the

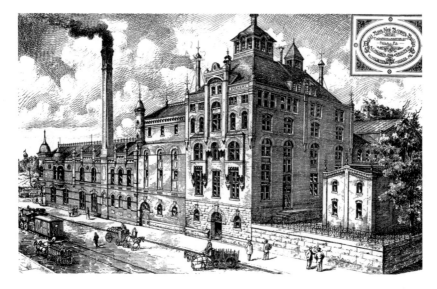

Weger Brothers' new brew house designed by A.C. Wagner, *Western Brewer*, 1893.

same block. After the death of his father, Charles T. Weger took charge of the business as executor of the estate, and in 1892, his brother, Frank Jr., joined him. The firm became known as Weger Brothers. In 1893, it had a new plant designed by A.C. Wagner, Philadelphia's second-most-prolific brewery architect and engineer. The brewery made Bavarian Beer, Erlanger Light and Hohenschwangau Export Dark. Annual production was around twenty-five thousand barrels.

George Keller

George Keller established a brewery on Third above Wildey Street in Northern Liberties in 1862. It remained in business for twenty years. In 1869, he acquired Saphir Lang's brewery on Thirty-first above Master Street, which added around six thousand barrels to his production. He built a new plant on Master above Thirty-second Street in 1881. The new plant had a fifty-barrel kettle that was set in brick and fired by anthracite coal. Refrigeration machinery was not installed until the mid-1890s. In 1891, his two sons joined the firm, which was incorporated as the George Keller Brewing Company. George died the following year, and the brewery remained in business until 1920. Its flagship brand was Troubadour Beer.

F.A. Poth

Frederick A. Poth came to America from Germany in 1861 and got a job working at Vollmer and Born's brewery in Brewerytown. Two years later, he set up a small brewery in Northern Liberties at Third and Green Streets, where he produced around five hundred barrels a year. In 1870, Poth returned to Brewerytown and purchased Bentz and Reilley's brewery on Thirty-first between Master and Jefferson Streets. A decade later, he built a large malt house. In 1881, Chicago brewery architect and engineer F.W. Wolf designed and built a new brew house outfitted with a 250-barrel steam-fired kettle. From 1892 to 1895, Otto Wolf completed a new brewery, two stock houses and a stable and enlarged an existing stock house. The new brew house was outfitted with two 370-barrel kettles. By the turn of the century, the brewery was producing around 200,000 barrels a year. Brands included Poth's Tivoli Export, F.A. Poth Brand Lager Beer, Poth's Extra and Special Pilsner.

Edward A. Schmidt married Poth's daughter, Emma, in 1885. Poth and Schmidt got involved in real estate development across the Shuylkill River in the city's Parkside section. When F.A. Poth died in 1905, he endowed an aqueduct, a school and a church for his German hometown of Walhalben, Rheinfalz.

The company purchased the Camden City Brewery in 1909, which added a potential of 100,000 barrels to its capacity.

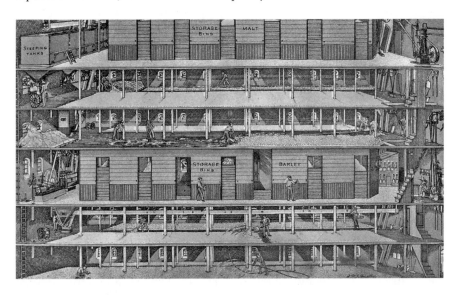

Interior view of Poth's malt house, completed in 1879. *Handy Collection.*

Henry Mueller's Centennial Lager Beer Brewery

Henry Mueller started a brewery in 1864 on Mascher Street just above Girard Avenue in Kensington. In order to keep up with the demand for his product, he purchased Born's brewery in Brewerytown and, in 1869, purchased a large tract of land at the northeast corner of Thirty-first and Jefferson Streets where he constructed large beer vaults. Four years later, he built a new brewery and moved all operations there. It was called the Centennial Lager Beer Brewery, but shortly thereafter, a refrigerated storage building collapsed due to the weight of the ice, killing nine and injuring eleven men. The building was rebuilt immediately.

By 1881, production had increased to 35,000 barrels, but in August of that same year, the brewery was destroyed by fire. Mueller rebuilt and was back in business by the end of the year but died in January 1882. His sons, Henry and Gustavus, took over the firm, which became known as the Estate of Henry Mueller. They brought production levels to 60,000 barrels per year. A fire destroyed a large portion of the plant in July 1890, and Otto Wolf was commissioned to build a modern 150,000-barrel brewery. The same year, Bergner & Engel purchased Mueller's brewery. The brewery was operated as Bergner & Engel's plant number two until 1900. Gustavus Mueller became a director of the Bergner & Engel Brewing Company before becoming president in 1903.

Eble and Herter

In 1870, Max Eble and Christian Herter had a hand-powered brewery on Richmond Street below Susquehanna in Kensington where they brewed 2,500 barrels a year. Three years later, they were operating a second brewery on Pennsylvania Avenue between Thirty-second and Thirty-third Streets. By 1876, they had moved all operations to Brewerytown and were producing over 10,000 barrels a year. A few years later, they purchased the adjacent brewery of Walter and Franz just to the west on Pennsylvania Avenue and were operating the malt house in the same block.

Bergner & Engel purchased Eble and Herter's brewery at the same time it purchased Mueller's. It became known as plant number three and served as the new ale and porter brewery. Plants one, two and three were located on contiguous properties and had a combined capacity of nearly 370,000 barrels. The brewery was remodeled in 1893.

Outdoor tavern sign, circa 1890s. *Flach family collection.*

American Brewing Company

In 1873, John Henzler and Henry Flach moved into Nentzel's brewery at the northwest corner of Thirty-second and Thompson Streets. They incorporated the business as the American Brewing Company in 1879 and built a new brewery called the Eagle Brewery on the site of Christian Renschler's brewery at the northwest corner of Thirty-first and Master Streets. John Henzler died in 1886, and the firm became known as Henry Flach and Sons. After the death of their father a decade later, his sons incorporated the firm as the American Brewing Company. By the turn of the century, the brewery had the capacity to produce over fifty thousand barrels annually. Brands included Majestic and Hercules Brau, as well as Flach's lager and porter.

Burg and Pfaender

Francis Orth was one of Brewerytown's early brewers shown on the *Hexamer General Survey* made in 1866. His brewery was located on Thirty-third below Master Street. Burg and Pfaender purchased it in 1885. They built a new brewery and stock house in 1892. The new plant was outfitted with a 325-barrel kettle and was illuminated with incandescent electric lights. Emma C. Bergdoll purchased the brewery in 1903. Peak production was just over 20,000 barrels per year.

Arnholt and Schaefer

The Born and Eisele Breweries were some of Brewerytown's oldest and went through a variety of owners until the Eisele brewery complex encompassed both properties. Henry Schaefer found employment with Goldbeck and Eisele when he immigrated to America in 1872. George Arnholt went into business with one of the members of the Goldbeck family in 1878, and they established a brewery in East Falls at Dutch Hollow. Schaefer became a clerk for the firm. Arnholt became sole proprietor in 1880 and, for three years, ran it as the Philadelphia Brewing Company.

In 1884, Arnholt and Schaefer acquired the Eisele Brewery. They incorporated as the Arnholt and Schaefer Brewing Company two years later and enlarged the plant to have a capacity of sixty thousand barrels. They made A&S Braun beer, ale, porter, stout, weiss beer, lager beer, Wiener Export, Ye Olde Brew and GERMALT Beer.

The founders of the firm died in the first years of the twentieth century. Schaefer's son, Charles, took over as secretary and treasurer and later became president. Charles Schaffhauser married one of Schaefer's daughters and became general manager. He is credited with expanding the bottling department and forming the S&S Water Company to manufacture soda in the years leading up to Prohibition.

Breweries South of Girard Avenue

Bergdoll, City Park Brewery

In 1857, Louis Bergdoll and Charles Psotta moved from their brewery in East Falls to an existing facility at Twenty-ninth and Parrish Streets, along the main line of the Pennsylvania Railroad. There were two malt houses on site in 1875, and they had a third in upstate New York. The combined production was 300,000 bushels, two-thirds of which was manufactured in Philadelphia. The brewery consumed 100,000 bushels, and the rest was sold on the open market. Production of beer was around 45,000 barrels.

Bergdoll became sole proprietor in 1871. A decade later, his sons, Louis and Charles, and two sons-in-law joined the firm, which was incorporated as the Louis Bergdoll Brewing Company. Otto Wolf completed thirteen projects to modernize and expand the complex, including a new malt house

CHAS. F. SCHOENING, Pres
MRS. E. C. BERGDOLL, Vice Pres
GEORGE RIEGER, Secty & Treas

The Louis Bergdoll

BREWING COMPANY

PROTIWINER EXPORT & LAGER BEER

Old Style Lager Beer

Office & Brewery
29th & Parrish Sts.

Bottling Beer a Specialty

TELEPHONE CONNECTION

Philadelphia, Pa., November 22, 1898.

Letterhead. *Handy Collection.*

in 1883 and a 100,000-barrel brew house and stock house in 1886. In 1894, a 170,000-bushel grain elevator was added along the rail line. By the turn of the century, production was over 150,000 barrels. The company had a fleet of fifteen trucks, and a new bottling house outfitted with modern equipment was completed in 1917. Its Protowiner and Old Style Lager were popular throughout the country.

Louis Jr.'s widow, Emma C. Bergdoll, was a major stockholder, and the family gained quite a bit of notoriety during World War I when her son, Grover Cleveland, and stepson, Erwin, evaded the draft. Grover attained national attention, and the papers were full of stories of where he was spotted or how "Ma Bergdoll" was hiding him. He even fled to Germany, where he evaded being drafted by the Germans. Among the collections of the Historical Society of Pennsylvania is an unpublished biography by Grover's son, Alfred, who evaded the draft during World War II, entitled *The Curse of the Bergdoll Gold.*

Jacob Conrad, Keystone State Brewery

Jacob Conrad learned the coopering and malting trades in Bavaria, Belgium and France before coming to America. He worked at George Lauer's brewery in Pottsville for two years and came to Philadelphia in 1849. He worked at Manger's brewery before becoming brewmaster at Dithmar's brewery in Northern Liberties. In 1850, he went to work in Perot's brewery but left due to ill health and went into the wine importing business.

In 1861, he was one of the first to enlist in the Union army and was the standard bearer for the First Regiment of Artillery of Pennsylvania. After serving the required three months, he reenlisted in the Sixth Army Corps and participated in twenty-four battles. At the Battle of Antietam, he was severely wounded and received an honorable discharge with the rank of captain in 1862.

After a decade in the wine importing business, he opened Jacob Conrad's Keystone State Brewery, named for the regiment he served with in the war. The brewery was located at Twenty-seventh and Parrish Streets, just two blocks from Bergdoll. It was powered with a small steam engine and had a forty-five-barrel steam-fired kettle. In 1890, refrigeration machinery was added, and production was around eight thousand barrels. The brewery closed in 1910.

Commonwealth Brewing Company

A block north of Conrad's brewery was another started by Charles C. Braunwarth at the northwest corner of Twenty-seventh and Cambridge Streets in 1886. It later was known as the Crown Brewery and was incorporated as Commonwealth Brewing Company in 1898. It had a bottling plant and warehouse across Cambridge Street, which was replaced with a large modern plant in 1911. The brewery produced up to twenty-five thousand barrels a year until it closed in 1916.

Fink Collection.

Peter Schemm

After dissolving his partnership with Bergdoll, Peter Schemm opened a saloon on Race above Second Street that became one of the main watering holes for the German population of the city. In 1856, he entered a

partnership with Louis Hauser. They established a brewery at the northwest corner of Twenty-fifth and Poplar Streets that also had a vault, saloon and dwelling. Schemm became sole proprietor and, in 1873, added an icehouse. Production was around ten thousand barrels.

In the late 1880s, Chicago brewery architect and engineer Frederick Wolf completed a modern 20,000-barrel brewery for the company. The brew house was equipped with a 125-barrel kettle. With additional improvements, production was brought to 50,000 barrels a year.

After the new brewery was completed, Schemm's son, Peter A., assumed more responsibility for running the brewery. This allowed the elder Schemm to spend more time visiting some of his favorite saloons to talk about the old days with his friends and to make sure his beer was being served properly. He had developed cataracts and could not bear the prospect of becoming blind. In September of 1898, he took a train to Niagara Falls and, while walking across the bridge to Goat Island, about one thousand feet upstream from the falls, climbed over the railing and plunged into the raging current. The waves tossed his body onto the rocks before it was sucked down the American Falls in full view of spectators at Prospect Point. His son-in-law went to Niagara Falls to lead the efforts to recover the body, but it was never found.

East Falls, Manayunk, Roxborough

John Stein, Fountain Park Brewery

Hilderbrand and Stein moved into Bergdoll and Psotta's brewery in East Falls in 1857 and began producing around five hundred barrels a year. The mansion had belonged to Governor Mifflin, Pennsylvania's first governor, who frequently entertained George Washington with shad dinners there.

In 1859, it became John Stein's Fountain Park Brewery, which included a hotel and summer park. The brewery produced around 2,500 barrels. In 1885, Henry Stein took over and ran the brewery for another five years.

Hohenadel Breweries

Jacob Hohenadel came to America from Germany with his family as a boy and worked on a farm in Lancaster County for six years. At the age of twenty,

he traveled to Philadelphia and found employment with Bergdoll and Psotta. In 1864, he established his own brewery near Broad and Cumberland Streets. Six years later, he moved to the old Steppacher brewery, north of Stein's, across what is now Midvale Avenue. Hohenadel called it the Falls Park Brewery. The six-acre property included a beautifully shaded park with large springs that was used for parties and picnics. There were vaults beneath the brewery, which produced around six thousand barrels a year. On the third floor above the brew house, there was a kitchen, lodging room and dancing saloon.

In 1875, Jacob's son, John, built a brewery just to the east on Indian Queen Lane and Conrad Street. The brewery began producing fewer than one thousand barrels and, in the years leading up to

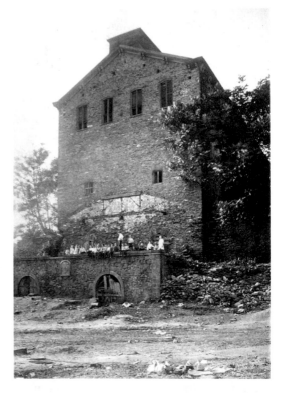

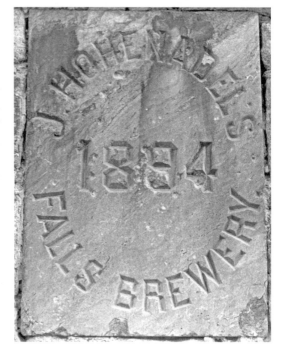

Top: Abandoned Hohenadel Falls Park Brewery near Midvale Avenue. *Print and Picture Collection, Free Library of Philadelphia.*

Bottom: Cornerstone to Hohenadel's modern brewery on Indian Queen Lane circa 1987. *Author's collection.*

Prohibition, was producing nearly thirty thousand barrels. Brands included Indian Queen Ale, Rival Porter, Alt Pilsner, Trilby Export, Hohen-Adel-Brau and Health Beer.

Philip Guckes

To the north and west of these breweries, Philip Guckes purchased a property in a deep hollow on School House Lane, below what is now Henry Avenue, in 1870. He was a well-established ale brewer from Northern Liberties who built a brewery and vaults for producing lager beer. There was a cold spring running through the vaults. There was also a pond to supply an icehouse capable of holding 1,600 tons of ice. Production was just over two thousand barrels. A decade later, Guckes put the property up for sale.

Liebert and Obert

Peter Liebert and Harmon Obert established a brewery in 1873 on Carson Street in Manayunk next to St. Mary's Church. Production was around six hundred barrels. In 1895, they commissioned Kurt Peuckert to design a modern brewery. Peuckert had spent five years working for Otto Wolf before starting his own firm. The new brewery included a large stock house, which was outfitted with Pflauder glass-enameled steel tanks. Maximum production prior to Prohibition was fifty-five thousand barrels in 1908.

Obscure Roxborough Breweries

There were at least two other breweries in the area, about which very little is known. Sometime before 1869, Darby, Louis and company started a brewery on Paoli Avenue between Ridge Avenue and the Schuylkill River. It is listed as Sebastian Nagle's Ale and Porter Brewery in the 1875 *Hopkins Atlas* and was in business until 1880.

The other was located on Thorps Lane, now a small spur called Old Line Road just above Ridge Avenue, off Bells Mill Road. It was established by William Wolf sometime before 1874 and changed hands twice before closing in 1884.

Fairmount

Philip Klein, Fairmount Avenue Brewery

In 1863, Philip Klein established a small lager beer brewery above Twenty-third Street, between Fairmount Avenue and Wallace Street. In addition to brewing, Klein was a distiller and rectifier of spirits. He also had a wholesale and retail wine and liquor business. There was a store and a bar with an office and bottling line on Fairmount, and the brewery buildings faced Wallace Street. In 1883, he remodeled the brewery. Seven years later, his son, Philip Jr., became a partner in the firm, and

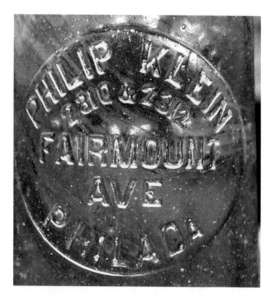

Embosssed bottle. *Davidson Collection*

they made more improvements. The brewery had a forty-barrel steam-fired copper kettle and produced around eight hundred barrels a year.

In 1893, the brewery was seized by the internal revenue collector over a two-hundred-gallon molasses rum distillery found on the premises. Philip Jr. was held on bail pending a hearing, but the district attorney did not pursue the case. Klein was indicted by a federal grand jury on similar charges in 1906 but was acquitted. A receiver was appointed for the brewery in 1912, and the brewery closed four years later.

Frankford and Bridesburg

Andreas Erdrich, Bridesburg Brewery

Lorenz Amrhein established a brewery in 1850 at Ash and what is now Edgemont Streets in Bridesburg. Andreas Erdrich was a foreman and

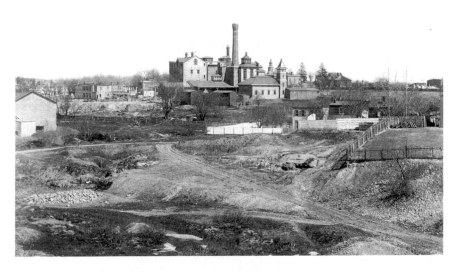

Erdrich's new brewery at Bridge and Walker Streets in Frankford. *Erdich family collection.*

purchased the brewery in 1866, when it became known as the Bridesburg Brewery. The plant was hand-powered and employed three men who produced 1,200 barrels. By 1878, production had more than doubled.

He built a modern brewery at Bridge and Walker Streets in Frankford in 1886 and continued to use the name Bridesburg Brewery. Production was around twenty thousand barrels. In 1891, the firm became Andreas Erdrich and Sons. Andreas died in 1898, and his son, John B., became proprietor. In the twentieth century, production reached nearly sixty thousand barrels. When John B. Erdrich died in 1925, his widow endowed the St. Bartholomew Memorial School in Frankford.

John Fritsch, Globe Brewery

Born in 1827 in Kenzingen, Germany, John Fritsch came to Philadelphia at the age of nineteen and became foreman in Blaess and Bergman's brewery in Northern Liberties. He married Elizabeth Blaess and took over Anthony Bechter's brewery at the northeast corner of Seventh and Fairmount Streets in 1855. Three years later, he opened a second brewery on Penn, just south of Ruan Street in Frankford, where he dug beer vaults. It became known as the Frankford Lager Beer Brewery.

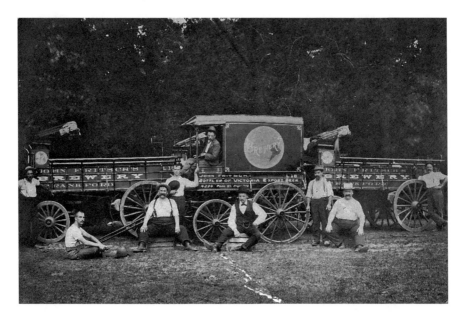

Two Fritsch brewery wagons used for delivering barrels flank a smaller one used for lighter loads. *Dikun Collection.*

By 1864, all brewing was done in Frankford with a production of around two thousand barrels. The brewery became known as the Globe Brewery in 1889. A decade later, his son, Emile R., became a partner, and the firm became John Fritsch and Son. In 1900, production exceeded ten thousand barrels. John Fritsch died two years later, and his son continued the business until selling out to W.H. Zimmermann, who formed the Zimmermann & Company Star Brewery in 1908. He was president of the Arnholt and Schaefer Brewing Company and manufactured Star Beer, cream ale and porter until 1916.

John Grauch

John Grauch began brewing on a small scale in 1850. In 1874, he started a brewery next to Fritsch with a production of two thousand barrels. He made additions to the plant that brought production to six thousand barrels. His flagship brand was Erminie Extra Fine Export Beer. After his death in 1877, the brewery was managed by his estate and became the Grauch Brewing Company from 1891 until the turn of the century.

Courtesy of the Wyck Association.

Germantown

Haines, Germantown Brewery

Caspar Wistar Haines was the eldest son of Reuben Haines and was involved with the family brewery on Market Street, along with his brother, Reuben. Both Reuben the elder and the younger died in 1793, and Caspar Wistar Haines built a brewery and malt house at the Wyck House, a family property, on Germantown Avenue. Today's Walnut Lane was built over part of the brewery site after it was razed. Caspar died in 1801, and his son, Reuben, who was only fourteen at the time, inherited the brewery. Reuben's son, John Smith Haines, was the last family member to be involved in the business. When his brewer, John Ladley, died in 1840, he closed the brewery, as it had been losing money due to the rising temperance movement, and he felt it had become a nuisance to his neighbors.

John C. Miller, Germantown Brewery

Frederick Jacoby, John C. Miller and Joseph Teufel formed a partnership in 1865 and established a small brewery at the southwest corner of Ashmead and Wakefield Streets. They delivered their four-hundred-barrel output with two delivery teams, one of which was driven by Miller. He became the sole proprietor in 1872 and produced twenty thousand barrels of ale, porter and brown stout. The brewery had agencies in Trenton, Norristown and in the state of Delaware. He died in 1886, and his son, George J., took over the firm, which was incorporated

as the John C. Miller Brewing Company in 1891. George added lager to the product line, and by 1895, the brewery had a capacity of eighty thousand barrels. In 1897, the brewery became a branch of a consortium of six local breweries known as the Consumers Brewing Company and remained in business until 1901.

Mutual Brewing Company

Lorenz Leiling started a brewery on East Queen Lane above Wakefield Street in 1888. It was located one block above Miller's brewery. Four years later, Leiling and four other investors put up ten thousand dollars and incorporated as the Mutual Brewing Company, which was chartered to manufacture malt and brew malt liquors. In 1897, it became a branch of Consumers Brewing Company and closed two years later.

Ad from Dunlap & Clark's *Liquor License Directory of Philadelphia and Principal Cities and Towns of Pennsylvania,* 1890. *Freeman Collection.*

Kensington

This neighborhood encompasses a much larger area than that occupied by the breweries of Brewerytown. Its boundaries may be likened to the pseudopods of an amoeba, in a constant state of flux. The breweries identified as being in Kensington are located in the area between the Delaware River and Sixth Street, and from the Cohocksink Creek north to Lehigh Avenue. The creek has long since been covered over, but it meandered from the area of Sixth and Master Streets southeast to where it entered the Delaware River near

Brown. Local historian and author Ken Milano examined the Philadelphia section in *American Breweries II* and identified over seventy locations occupied by breweries in the neighborhood throughout time. According to that assessment, Kensington's earliest brewery appeared in 1843. Further research may find earlier brewers in the neighborhood.

F.W. Salem's book, *Beer, Its History and Its Economic Value as a National Beverage*, published in 1880, contains production figures for the nation's breweries in 1878 and 1879. Kensington had nearly thirty breweries in 1879, which produced just over 36,000 barrels. The same year, fifteen breweries in Brewerytown produced over 320,000 barrels or about half of the total beer produced in the city. Schmidt's was the only Kensington brewer producing over 10,000 barrels, and Bergner & Engel was the only company in Brewerytown producing over 100,000 barrels.

Christian Schmidt, Kensington Brewery

Christian Schmidt learned the brewing trade in Stuttgart and came to America at the age of eighteen. He worked in various breweries in Philadelphia for about eight years before becoming foreman at Coutrennay's brewery on Edward Street, near Second Street and Girard Avenue. The 1860 census shows that the brewery had been in business for four months and produced 400 barrels of ale and 55 barrels of porter. Christian Schmidt became sole proprietor and a decade later added a malt house with a capacity to produce fifty thousand bushels per season. Beneath the malt house was a cellar capable of holding 4,000 barrels of beer. The brew house did not have a copper kettle but rather a wooden tub where 120 barrels of wort was boiled using an immersed coiled steam pipe.

A new brewery and large refrigerated stock house was added in 1880 to accommodate the production of lager beer. The brew house had a 110-barrel copper kettle for brewing lager, and the wooden tub continued to be used for ale. Five more buildings were added a few years later for refrigerating machines, additional fermenting space, wagon storage and coopering. In 1892, the firm became known as Christian Schmidt and Sons with the admission of Edward A., Henry C. and Frederick W. to the firm. Christian Schmidt died in 1894, and his son, Edward A., became president. Schmidt purchased the Robert Smith Ale brewery at Thirty-eighth and Girard in 1896, which added 50,000 barrels of production to the 100,000 barrels produced in Kensington. The brewery adopted the Pfaudler vacuum fermentation system, and in 1914, Otto Wolf designed a new brew house and power plant, doubling the brewery's capacity.

Elizabeth Vollmer

In 1860, Martin Schurr had two breweries producing a total of 1,000 barrels of beer. One was located at the southeast corner of Randolph and Jefferson Streets. The other was just south on the west side of Randolph above Master Street. Leonard Otterbach took over the breweries in 1877 and rented them to August Vollmer. Otterbach died five years later, and his widow married Vollmer. The plant at Randolph and Jefferson Streets was rebuilt around this time, and Vollmer ran the breweries for seven years until he died in 1889, when Elizabeth Vollmer became proprietor. She built a modern brewery at the southern location in 1893 and continued to run both plants. The new brewery had a 125-barrel kettle. The older brewery had a 40-barrel kettle and subsequently became the brewery's bottling works. In the years before Prohibition, production was approaching 25,000 barrels.

Rieger and Gretz, Tivoli Brewery

Albert Schwarz started a brewery near the intersection of Fourth Street and Germantown Avenue in 1861. Leonard and Frank Rieger and William Gretz purchased the plant in 1878 and called it the Tivoli Brewery. They built a new bottling house in 1894 and added a four-story stock house and boiler house. Peuckert and Wunder completed seven expansion projects for Rieger and Gretz after the turn of the century. Production exceeded forty thousand barrels in 1914.

Rieger & Gretz calendar, 1912.
Fink Collection.

Fred Feil

Fred Feil was born in Stuttgart, where he learned the brewing trade. He came to New York at the age of seventeen and worked in the F&M Schaefer brewery for four years, then moved to Philadelphia and worked at Bergner & Engel's brewery for four years. Feil married Louise Schaefer in 1877 and, the following year, purchased a small weiss beer plant with a saloon, where he produced around four hundred barrels of lager beer.

Feil rebuilt the brewery in 1884 and added an icehouse and fermenting cellar. He purchased pre-milled malt for brewing and ice for refrigeration. The brew house had a 35-barrel copper kettle fired directly by anthracite coal. In 1892, he built a new brew house with a 125-barrel steam-fired kettle. This included a malt mill and refrigeration machines. Otto Wolf completed a stable and stock house in 1896. Two years later, he added another stock house, as well as an ice machine house. Production was over thirty thousand barrels at the turn of the century. In 1907, Kurt Peuckert furnished plans for a modern bottling house. Brands included Favorite Light, Exquisite Dark, Stuttgarter and Feil's lager beer.

Theodore Finkenauer

Carl Kramer set up a small weiss beer brewery on Germantown above what is now Cecil B. Moore Avenue in 1868. Anton Walz took over in 1873 and brewed in a four-barrel kettle. Theodore Finkenauer purchased the brewery three years later. He had come to Philadelphia at the age of twenty and got a job at Bentz and Reilly's brewery in Brewerytown, becoming brewmaster after Poth purchased the plant.

He made improvements to the plant and, by 1890,

Handy Collection

was producing fifteen thousand barrels of lager beer. The following year he built a new brew house, added a boiler house and doubled the size of his fermenting cellar and stock house. Otto Wolf made further alterations in 1895 and completed five more projects from 1900 to 1904, including a new brewery, boiler and stock houses, and he enlarged the ice machine house. Production in 1902 exceeded sixty-six thousand barrels.

The firm was incorporated in 1908 as the Theodore Finkenauer Brewing Company. Theodore Jr. went to the Chicago Brewers' School and, while there, worked in the Schoenhofen brewery, where he made a special study of yeast culture. Its brands included a light Elmer Export and dark Genuine Old Lager.

William A. Heimgaertner, Kensington Brewery

Moritz Ruoff started a weiss beer brewery in 1874 on Frankford Road just above Girard Avenue. In 1882, William A. Heimgaertner took over the plant. In 1898, he installed a new fifty-barrel kettle and surface cooler. In 1906, the name changed to Kensington Brewery. Heimgaertner died the following year, and his estate conducted the business until 1910, when the name was changed to the Frankford Avenue Brewery. William J. Sheehan purchased the brewery that year, and it became known as Protobrewing Company. Products were Protos Light and Dark Beer, and peak production was twenty-six thousand barrels. A new pasteurizer was installed in 1917, but the company went out of business that year.

Weisbrod and Hess, Oriental Brewery

George Weisbrod learned the brewing trade in Germany and immigrated to New York City at the age of seventeen. He worked there and in the New England states before coming to Philadelphia in 1873, where he worked in the Bergner & Engel and Prospect breweries.

Christian Hess emigrated from Germany in 1866 and came to New York City, where he learned to be a butcher. Two years later, he came to Philadelphia and went into business. In 1881, he and George Weisbrod became partners and moved into a brewery and saloon on Germantown Avenue above Diamond Street. In 1883, they were also brewing at Zimmerman Hall on Frankford Avenue and Amber Street. Within two years, all operations were being conducted at Zimmerman Hall.

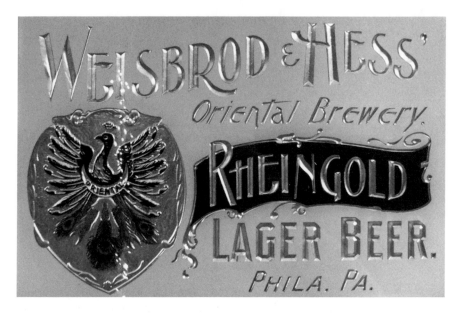

Reverse on glass sign. *Handy Collection.*

They remodeled the brewery, and by 1890, production was nearly 30,000 barrels. That year, they had brewery architect and engineer A.C. Wagner design a modern plant. The brew house was outfitted with a 250-barrel kettle, and production was nearly 90,000 barrels by the turn of the century, when the brewery employed one hundred men. Brands included Rheingold Lager, Shakespeare Ale, Kulmbacher Pilsner, Franciskaner, Bohemian and Wiener Export. Both partners died in 1912, and the firm continued under the management of family members.

Joseph Straumueller and Son

In 1882, Joseph Straubmueller established a brewery across Frankford Avenue from Weisbrod and Hess at York Street, Trenton and Boston Avenues. By 1890, production was nearly ten thousand barrels. Straubmueller had A.C. Wagner design a modern plant the same year he executed the project for Weisbrod and Hess. The brew house was outfitted with a one-hundred-barrel kettle. Five years later, more land was purchased, and a new refrigeration plant and stock house were constructed. In 1905, the firm became known as Joseph Straubmueller and Son. Two years later Kurt Peuckert made plans for a new stock

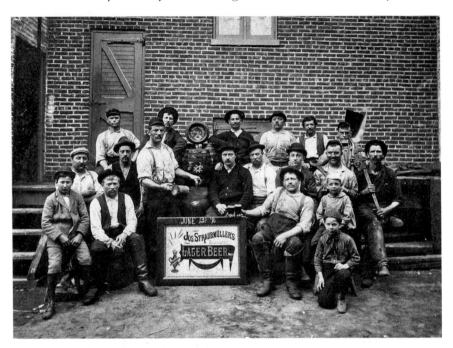

Straubmueller brewery workers, June 1896. *Cartin Collection.*

house, wash house, bottling plant and wagon house. Production in the twentieth century approached twenty-five thousand barrels. Brands included Sunshine Light, Ulmer Doppel Dark and Special Brew.

Philip Zaun's Weiss Beer Brewery

Berliner Weisse, or white beer, is a style that was popular with German Americans in the second half of the nineteenth century. Its origins date back to the sixteenth century, and it was said to be the brewers' answer to Riesling wine. It became popular with French Huguenot refugees in Berlin, and Napoleon's occupying forces called it "le Champagne du Nord." Its lightness was derived from wheat in the malt bill, and its characteristic sourness was due to the fact that it was fermented with a combination of ale yeast and *lactobacillus*. American brewers substituted copious quantities of corn for wheat in the recipe. In Berlin, the wort was not boiled but went from the mash tun to surface cooler and then into the fermenter. The beer was aged for a very short time and bottle conditioned. This reduced the amount of infrastructure needed for its production, and quite a number of small weiss beer breweries proliferated in areas where Germans settled.

August Winnig started a weiss beer brewery in 1860 at Twenty-fifth Street and Fairmount Avenue. He moved to Third Street below Fairmount Avenue in Northern Liberties in 1863. Philip Zaun took over the business a decade later and, in 1885, relocated to Germantown Avenue below Jefferson Street. The brewery produced around three thousand barrels per year. Mr. Zaun died in 1901, and his son-in-law, Karl Newman, and son, Harry Zaun, carried on the business until 1912.

North Philadelphia: Broad and Cumberland

The 1875 *Hopkins Atlas* shows a cluster of four breweries on the east side of Broad near Cumberland Street. John Hohenadel had taken over his father Jacob's brewery to the north of Cumberland and was producing around two thousand barrels of beer per year. The brewery was separated by a railroad line from Oakdale Park, which had a large pond suitable for ice harvesting. There was a creek flowing on his property, and south of Cumberland Street, there were two breweries near where the creek was met by a branch that connected with the pond.

Furthest to the south was the Louis Gross brewery, which was established in 1868 at the confluence of the creeks. He had a hand-powered plant, which was producing two thousand barrels of beer worth $20,000 in 1870. His estate managed the brewery until 1884, when it was sold to Frederick Schwamb, who remained in business until 1895.

Joseph Feilmeyer's brewery was north of Louis Gross. In 1878, production was nearly three thousand barrels. His sons continued running the plant until 1891.

Christian Klopfer started a brewery to the north of Feilmeyer in 1878, producing around 1,500 barrels. The brewery changed hands twice from 1885 until 1891, when it was known as the Broad Street Park Brewing Company. The following year, Charles Schwerdfeger renamed it the Golden Eagle Brewery. Brands included Caramel Malt Beer and Pelusium. In 1903, John Roehm purchased the plant and moved there from his brewery in Northern Liberties.

Spaeth Krautter and Hess, Anchor Brewery

In 1886, John Spaeth, Louis Krautter and Henry Hess opened the Anchor Brewery at the northeast corner of Germantown and Lehigh Avenues. For the first two years of operation, they also owned Enser and Theurer's brewery at Second and Ontario Streets. Henry Hess was one of the organizers of the Consumers Brewing Company, of which Spaeth Krautter and Hess became a part. The brewery had a 250-barrel kettle and produced around 45,000 barrels a year. Brands included Monte Carlo, Capuziner and Bismark Beers. It was known as the Spaeth and Hess Department of the Consumers Brewing Company from 1899 until it closed in 1904.

Gottlieb Manz, Bavaria Brewery

Gottlieb Manz established a brewery on Frankford above Girard Avenue in 1864. Six years later, he opened a second brewery at Sixth and Clearfield Streets. Production was around 1,500 barrels. In 1878, a new brewery, including refrigeration machinery, doubled the output. A few years later, a dynamo house was built, and steam and refrigeration capacity was increased. The firm was incorporated as the Philadelphia Brewing Company in 1893. Otto Wolf executed six projects for the company, including two stock houses and a new brewery in 1902. By the first decade of the twentieth century, production was close to 70,000 barrels a year. Brands included Lorelei and Walhalla Beers.

Amrhein Independent Brewing Company

Lorenz Amrhein started brewing in Bridesburg in 1850. After selling his brewery to Andreas Erdrich in 1868, he moved to Front above Jefferson Streets, where he had a brewery and lager beer saloon. Four years later, he moved to Sixth Street below Clearfield, across from Manz, and was brewing around two thousand barrels a year. In 1890, he partnered with his son-in-law, Albert Hoch. The flagship brand was Kyffhauser Beer. Three years later, George and Joseph took over as Amrhein Brothers, and in 1898, the firm was incorporated by a consortium of local bottlers as the Independent Brewing Company. In 1913, the last year of operation, the brewery produced thirty thousand barrels of beer.

Jacob Hornung, Tioga Brewery

Jacob Hornung came from a long line of brewers in Heimsheim, Germany. In 1879, he came to Philadelphia and, together with his wife, set up a saloon with a four-barrel brew house and began selling beer in stoneware jugs for twenty, thirty and forty cents. His wife recalled many years later that on some Saturdays they took in as much as $200 or $300. In 1885, he purchased a property at the northeast corner of Twenty-second and Clearfield Streets and built a brewery and bottling establishment. Architects Peuckert and Wunder added a stock house in 1899 and executed five more projects prior to Prohibition, including a modern bottling plant in 1911.

A neighborhood man approached Mr. Hornung with a goat outfitted with a harness and hitched to a small wagon. Jacob had been trying to come up with a symbol for his beer, and as soon as he saw the goat, he exclaimed, "That's it. I'll call the beer White Bock!" The goat's portrait became his trademark and adorned labels and signs. Hornung's White Bock Beer won the grand prize at the Paris Exposition in 1912. Other brands included Heimsheimer and XX Porter. Prior to Prohibition, production was as high as thirty thousand barrels a year.

Today's Temple University Neighborhood

Charles Wolter, Prospect Brewery

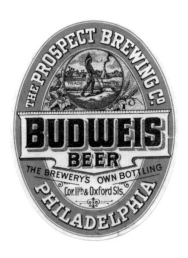

The area between Tenth and Broad Streets and between Oxford and Montgomery Avenue was home to seven breweries. The earliest was a small lager brewery established in 1848 by Andrew Wirth and Frederick Schaffer at the northwest corner of Eleventh

Budweis is a town in the present-day Czech Republic famous for its lager beer. The term was used to describe a beer style like that brewed there, and many brewers had Budweis or Budweiser brands. *Handy Collection.*

72

and Oxford Streets. Francis Beckler purchased it in 1851 and converted it to an ale brewery and added a malt house. Production was around 1,400 barrels, most of which was sold at a hotel across from the brewery. Ignatz Beckler became owner, and in 1873, he replaced the old brewery with a new plant capable of producing 35,000 barrels a year. The malt house had a capacity for 160,000 bushels per season.

In 1877, Charles Wolters purchased the brewery for the purpose of manufacturing lager beer and malt extract. In 1886, the firm was incorporated as the Prospect Brewing Company. A.C. Wagner executed a modern six-story bottling house, refrigeration machine house and offices. Production exceeded seventy-five thousand barrels in the twentieth century. Brands included Prospect Lager Beer, Export Light, Budweis Beer, Bohemian Export, Muenchener P.M. Dark, Porter and Hercules Malt Extract.

Catherine Nichterlein, Columbia Brewing Company

Charles Kasper had a brewery in Northern Liberties for twenty years before moving to Mervine Street, just above what is now Cecil B. Moore Avenue, in 1884. Theodore Nichterlein purchased the brewery in 1891. He died two years later, and his widow became proprietor. The firm was incorporated as the Columbia Brewing Company in 1898. The brewery was outfitted with a new kettle and surface cooler and remained in business for four more years producing its flagship Thueringer Export.

Consumers Brewing Company, Excelsior Brewery

In the block north of the Prospect brewery, there were three breweries on Mervine Street below Montgomery Street. The first of these was established in 1861. Christian Haisch purchased the brewery in 1877 and produced around five thousand barrels a year. Seven years later, John Kellerman, Edward Nichterlein and Mary Haisch became partners, and in 1892, the firm was incorporated as the Excelsior Brewing Company. Its beer was known as Edelweiss. When the Consumers Brewing Company was formed in 1897, Excelsior became a branch of that company, and John Kellerman was on the board of directors. Consumers had financial difficulties and was reorganized in 1900. The Excelsior plant was closed four years later.

Class and Nachod

Ferdinand Steinbach started a brewery in 1853 on Mervine Street below Montgomery. Charles Class became proprietor a decade later. In 1870, production was around two thousand barrels of beer, ale, porter and lager beer. The following year, Charles Jr. took over the brewery. In 1890, he formed a partnership with Julius Nachod, and they modernized the plant with the installation of Pfaudler tanks. Two years later, Charles Bremer's brewery on Germantown Avenue east of Broad Street was incorporated as the Rising Sun Brewing Company, with Charles Class as principal stockholder. The Class and Nachod Brewing Company was incorporated in 1896, and they purchased the Rising Sun Brewing Company shortly thereafter.

By 1905, the company was producing nearly sixty thousand barrels per year. In 1911, Class and Nachod commissioned architect Charles H. Caspar to design a modern brewery that was erected at the northeast corner of Tenth and Montgomery over a period of years. After the new brewery was completed, they closed the plant on Germantown Avenue and renamed the brewery on Mervine Street the Rising Sun Brewing Company. Brands included Solitaire Pale and Kohinoor Dark and Volksbrau.

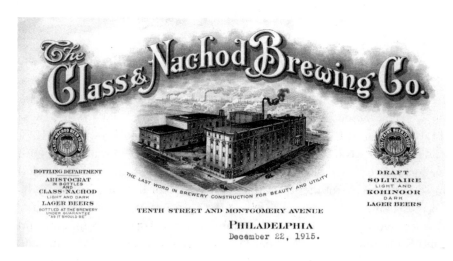

Letterhead. *Handy Collection.*

A Heady History of Brewing in the Cradle of Liberty

Schweitzer and Grim

From 1862 until 1875, Schweitzer and Grim had a brewery at the northwest corner of Eleventh Street and what is now Cecil B. Moore Avenue. They produced around four thousand barrels annually. The partnership also had a brewery on Third Street, below Poplar Street, from 1859 until 1868.

Germania Brewing Company

Philip J. Lauber established a brewery at the northwest corner of Broad Street and what is now Cecil B. Moore Avenue, in 1875. An advertisement in the *Evening Bulletin* in 1882 promoted the opening of Lauber's Grand Concert Garden, where members of the Germania Orchestra were to perform. That year, Laubner was arraigned for violating the Sunday laws by selling lager beer. The *Western Brewer* called the action "teetotal fanaticism" induced by the so-called Law and Order League.

John F. Betz purchased the brewery that became the Germania Brewing Company in 1886. He had Otto Wolf build a 100,000-barrel plant. This included a large opera house to the north of the brewery on Broad Street. There was also a bottling house connected with the brewery operated by Edwin F. Poulterer, who was president of Germania Brewing Company in 1892.

In 1901, Henry Hess, former president of the struggling Consumers Brewing Company, leased the brewery from Betz, and it became the Henry Hess Brewing Company. Brands included Vienna Light Beer and Munich Dark Beer. The brewery never produced more than about half of its capacity and went out of business in 1911.

John Weihmann

At the age of thirty, John Weihmann came to Philadelphia from Bavaria. He and Charles Rittmaier were proprietors of the Bush Hill Brewery for five years. He acquired a property at the corner of Callowhill and Tenth Streets and set up a brewery and meeting hall. He produced around two thousand barrels a year. After Weihmann retired in 1897, Louis Krautter took over the business, which he called the Union Brewing Company until 1901.

George Esslinger

In 1868, George Esslinger started a small lager beer brewery on Tenth Street above Jefferson Street, where he produced between five hundred and one thousand barrels a year. Eleven years later, he moved to Tenth above Callowhill Street, near Weihmann's brewery. In 1893, the firm became known as George Esslinger and Son and was producing around five thousand barrels. Brands included Adonis, Columbian, Export Beer, ale and porter. When the Union Brewing Company closed at the turn of the century, the property was acquired by Esslinger, whose production grew to twenty-five thousand barrels.

Northern Liberties

Originally, Northern Liberties was all the land above Vine Street, which was then the northern boundary of the city. Today it is generally described as the area between Spring Garden and Girard Avenue and from the Delaware River and Sixth Street. A portion of "Olde Kensington" lies within this area above where the Cohocksink Creek used to flow. Northern Liberties has been home to over one hundred breweries throughout its history. There were eighteen active breweries there in 1879 producing over twice as much beer as those in Kensington but less than a quarter of Brewerytown's production. John F. Betz was the largest, producing nearly 45,000 barrels. Two ale brewers were producing over 10,000 barrels, and there were a dozen that produced fewer than 1,000 barrels. By 1915, there were only a half dozen breweries producing fewer than 300,000 barrels, or less than 15 percent of the city's total output.

John F. Betz

Betz came to America with his family as an infant. His father went into the saloon business in Pottsville. John F. became an apprentice in the brewery of his brother-in-law, D.G. Yuengling, then spent a year in Germany and Austria working in breweries there. He returned to the United States in 1853 and formed a partnership with Henry Clausen in New York City called Clausen and Betz, Eagle Brewery.

In 1867, he came to Philadelphia and purchased Gaul's brewery on Callowhill and New Market Streets, which was said at the time to be the

oldest brewery in the nation, having been founded by Robert Hare in 1774. Betz started out making fewer than 30,000 barrels of ale and porter. A decade later, production was 50,000 barrels, and he had a malt house a few blocks away on what is now American Street that was capable of producing 250,000 bushels per year. In 1880, he built a modern brewery on Callowhill above Fourth Street that had a capacity of 200,000 barrels a year. Betz continued to have financial interests in several breweries in New York City and was one of the largest brewers in the country.

His beer was shipped both bottled and draft throughout the United States, the Caribbean, Mexico, South America and Japan. Although the brewery specialized in ale, porter and brown stout, lager brands included Bohemian, Pale Export, Salvator, Munich and Betz's Best. A booklet published by the company describing its products stated that Betz's Burton Ale was four years old at the time of bottling. East India Pale and India Pale ales were 6.5 percent and 7.5 percent alcohol, respectively, and were guaranteed to keep in any climate. Brown Stout was recommended for "invalids of both sexes requiring a gentle and strengthening tonic," as well as for nursing mothers. Half and Half was made with two-year-old ale and stout. At the New Orleans Exhibition in 1885, Betz received gold medals for its East India Pale Ale and Double Stout. The brewery won four medals at the Chicago World's Fair in 1893 for East India Pale Ale, Extra Brown Stout in bottles and Burton ale in bottles and draught.

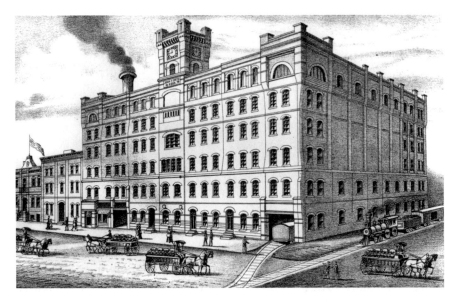

Modern plant of the Betz brewery at Fifth and Callowhill Streets, *Western Brewer*, 1881.

John F. Betz built one of the city's first skyscrapers, known as the Betz Building, on Broad Street and South Penn Square. He owned the Grand Opera House, Riverside Mansion, Fairmount Park Inn and the Lyceum Theater and had a farm of over one thousand acres called Betzwood in Montgomery County. Prior to his death in 1909, he transferred the title of his brewery to his son and the Germania brewery to his grandson. His obituary said he owned more corner properties than any other citizen in Philadelphia.

Philip Guckes, International Brewing Company

Philip Guckes was born in Germany, where he learned the brewing trade. He came to America and worked in breweries in New York and Philadelphia, where he spent seven years at Rudman's brewery. In 1850, he started a brewery at Front and Green Streets, where he brewed around six barrels of table beer per week. The business included a store that sold lager beer. Two years later, he moved to Brown Street and doubled his output, adding ale and porter to his product line. In 1854, he moved to Third Street, below Poplar Street, and began producing around forty barrels of ale and porter per week. He built a malt house two years later capable of producing four thousand bushels per season. Although his business continued to increase, the rising popularity of lager beer was adversely affecting ale brewers, so he built a lager brewery on School House Lane in Roxborough in 1873. The firm became known as Philip Guckes' Sons in 1884 and, a decade later, was incorporated as the International Brewing Company. When he died in November 1897, he was said to be the oldest active brewer in the city, if not the nation. The brewery closed two years later.

Binder, Biederbeck and Shmidheiser

Philip Blaess and Henry Bergmann started a brewery on what is now American Street above Green Street in 1850. The same year, Gottlieb Schweikert established a brewery two doors south of them and brewed around three hundred barrels a year. Blaess and Bergmann closed in 1862, and Charles Kasper purchased Schweikert's brewery. He increased production to one thousand barrels. Gottfried Binder acquired the plant

in 1883 and formed a partnership with Christian Biederbeck and his brother-in-law, H. Shmidheiser, in 1897. That year, they contracted with Otto Wolf for a modern thirty-thousand-barrel brewery that encompassed the old Blaess brewery site. In 1912, the brewery produced eighteen thousand barrels. Brands included Tubinger Tafel Beer and Kitzinger Export.

Trupert Ortlieb, Victor Brewery

Trupert Ortlieb was born in 1839 in Baden. He learned the brewing trade and immigrated to New York City at the age of twenty, finding work in a brewery there. Two years later, he enlisted in Private Company G of the Forty-first Regiment of Infantry in New York. He was wounded and mustered out in June of 1864. Four months later, he signed up with a unit from New Jersey and was discharged in July 1865. He came to Philadelphia and opened a small weiss beer brewery near Third Street and Germantown Avenue. In 1879, he purchased a brewery on Third Street, south of Poplar, that had been run by Schweitzer and Grim and called it the Victor Brewery. His beer was highly regarded by connoisseurs. Trupert had a daughter and six sons. In 1893, his eldest son, Henry T. Ortlieb, became president of the firm. He was succeeded a year later by Henry F., and the brewery began to be known by his name. At the time, production was fewer than two thousand barrels, and Henry began modernizing the plant. By the time Prohibition arrived, production was up to thirty thousand barrels.

John Roehm, Consumers Brewing Company North Plant

John Roehm was born in Bavaria and apprenticed in a large brewery in his hometown. He came to Philadelphia in 1867 and went to work at the Bergdoll brewery He ran a saloon on Green Street for ten years and then purchased Anton Stroebele's brewery on Fourth Street south of Poplar in 1888. Architect A.C. Wagner executed a modern seventy-five-thousand-barrel brewing plant for Roehm in 1891. Six years later, it became a branch of the Consumers Brewing Company, of which John Roehm was a director.

Roehm purchased the Golden Eagle Brewery on Broad Street in 1903. The Northern Liberties plant was Consumers' north plant until

1909, when it became the Henry Hess Brewing Company. Otto Wolf was commissioned to renovate the plant, and in 1913, the firm became known as the Premier Brewing Company. Production reached forty-five thousand barrels in 1915.

John Jacob Wolf

On Fifth Street, north of Poplar, there were two breweries with lager beer saloons. Christian Schnitzel started one in the middle of the block around 1857, shortly after he established one of the earliest breweries in Brewerytown. Adam Miller took over in 1867 and produced around three hundred barrels a year. The brewery went through a variety of owners before going out of business in 1884.

A few doors down, Adam Miller started a similar establishment in 1871, producing fewer than five hundred barrels a year for about a decade. John Jacob Wolf became proprietor in 1886 and built a more substantial brewery. Peuckert and Wunder designed a modern bottling house that went into operation in 1917. Production at the time was nearly twenty thousand barrels. Brands included Wolf's lager beer, pure malt beer, cream ale, porter and tonic.

Christian Muellerschoen's Weiss Beer Brewery

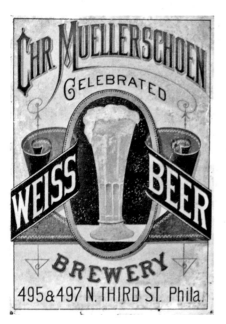

Weiss beer's popularity in Philadelphia and other cities with large German populations rose in the late 1860s. In 1879, there were fifteen weiss beer plants in the city, and by 1890, there were only a half dozen. The top-fermented, highly carbonated unfiltered beer was said to be refreshing and was frequently served with a shot of raspberry or woodruff syrup to cut the sourness.

Muellerschoen was the last of Philadelphia's many weiss beer breweries when Prohibition arrived in 1920. *Handy Collection.*

Christian Muellerschoen established a weiss beer brewery and saloon in 1878 on Third Street, just below Buttonwood, with a production of fewer than 100 barrels. His widow took over four years later. Andrew Rudolph ran the plant until 1902, when the founder's son, John C. Muellerschoen, became proprietor. In 1912, the brewery produced 3,500 barrels. It was the last weiss beer brewery remaining in the city in 1920.

South Philadelphia

Southwark Brewery

Originally, Southwark included everything below South Street, the southern boundary of the city. Of the breweries listed in *American Breweries II*, there are only thirty-three located in this area, with the earliest appearing in 1736. Sometime before 1788, William Miller established a brewery on Vernon Street, between Front and Second Streets, just below South Street. William Innis purchased the brewery and, in 1790, moved to the east side of Front Street below what is now Kenilworth. Nine years later, he sold the brewery to George Rehn, who named it the Southwark Brewery. In 1850, Frederick Flurer was brewing beer, ale and porter there. John Schoch was reported to be making 150 barrels of lager beer at the brewery a decade later. This brewery lasted over eighty years, making it South Philadelphia's longest-running brewery. After 1869, Schoch ran it as the Southwark Malthouse.

John Gardiner, Continental Brewing Company

James Smyth established a brewery at the southwest corner of Twenty-first and Washington Streets in 1869. He had two cellars, one for present use and the other for stock or aged ale. He produced 7,500 barrels of ale, 2,000 barrels of brown stout and 500 barrels of porter. Smyth also operated the malt house of the Morris Brewery at Dock and Pear Streets where he produced sixteen thousand bushels of malt. The combined value of his products was $100,000.

John Gardiner learned the brewing trade from his father in upstate New York and came to Philadelphia in 1849 at the age of twenty-four to work at Massey's brewery. He married one of Christian Schmidt's daughters, Caroline, and in 1866, he became a member of the firm. Eight years later, he and Charles

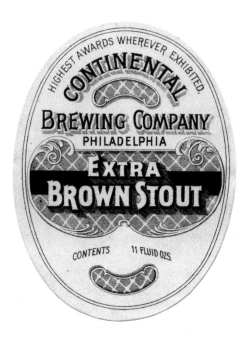

Yards Brewing Company used this design for its first ESA label. *Handy Collection.*

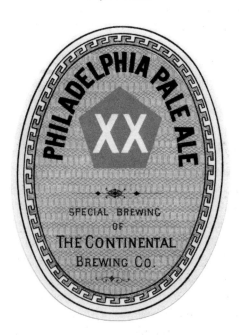

This pre-Prohibition brand lives on in name only as Yards Philly Pale Ale. *Handy Collection.*

Topping purchased Smyth's brewery, and it became known as John Gardiner and Company.

Gardiner's porter was commended for excellence in taste, aroma and brightness by judges at the Centennial Exhibition in 1876. His son, John Jr., was admitted to the firm, and in 1879, a modern brewery and malt house was designed by Philadelphia architect John K. Yarnall. This included the installation of electric generators, which made Gardiner's the first brewery in the world to be illuminated with electric arc lights. The malt house had a capacity to produce 150,000 bushels.

The firm was incorporated as the Continental Brewing Company in 1883. Refrigeration equipment was installed, facilitating the production of lager beer. More expansion was made in 1892, including the addition of incandescent light machines. Motive power was also supplied by electricity, an innovation that would eventually replace steam engines in modern plants. Production was eighty thousand barrels of lager and twenty thousand barrels of ale and porter.

Continental's trade extended beyond the United States to the Caribbean, South America, Spain and Portugal. Brands included Premium Beer, Gardiner's Special

Beer, Philadelphia Stock and Pale Ale, Burton Ale, India Pale Ale, Extra Brown Stout, Double Extra Stout, Philadelphia Porter, Bock Export Beer, Half (Ale) and Half (Stout), Inverness Brand Scotch Ale, Extra Gold Seal Beer and Turf Villa Special Brew.

Frank Baierle Ale and Porter Brewery

In 1867, Frank Baierle established a brewery at the southwest corner of Sixth and Pierce Streets. The building was four stories, with a cellar for storing beer. The plant was powered by steam and produced two thousand barrels of ale and porter in 1870. The brewery closed in 1872.

Welde and Thomas, Consumers Brewing Company

John Welde established a brewery at the northeast corner of Broad and Christian Streets in 1884. The following year, he formed a partnership with John Thomas.

In 1886, they moved to Moore's brewery and replaced it with a modern brewery equipped with Pfaudler glass-enameled tanks. In 1890, they replaced the mash tub with one of an innovative design for mashing under high pressure, giving the plant a capacity to brew 50,000 barrels a year. A pure yeast apparatus was installed, and John Welde Jr. was the brewery's chemist. The *Western Brewer* reported that the company had experienced

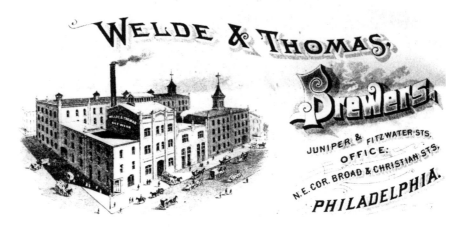

Welde and Thomas was Consumers Brewing Company's south plant. *Author's collection.*

a 1,300 percent increase in sales since building the new plant, explaining that they formed the Consumers Brewing Company in order to supply the demand. The stock corporation was composed of six breweries with a combined capacity of 300,000 barrels. John Thomas died in January 1899. The following year, Consumers was placed in the hands of a receiver. John Welde died in 1901.

When the north plant was sold in 1909, the south plant was all that was left of Consumers Brewing Company. Production was around sixty thousand barrels. In 1910, Otto Wolf, a director of the company, prepared plans for a storage house, cooper shop, wash house and racking room. Brands included Sanitas Beer, Penn Beer, and Quaker Beer, ale and porter.

Spring Garden

Joseph Kohnle

Rittmaier and Weihmann founded the Bush Hill Brewery in 1866 on Buttonwood above Seventeenth Street. Joseph Kohnle purchased the brewery in 1882. He had been operating two breweries from 1874 until 1880. One was called the Schiller Park Brewery, located along the

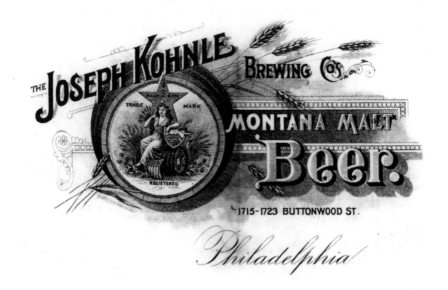

Descendant of Joseph Kohnle's family collection.

84

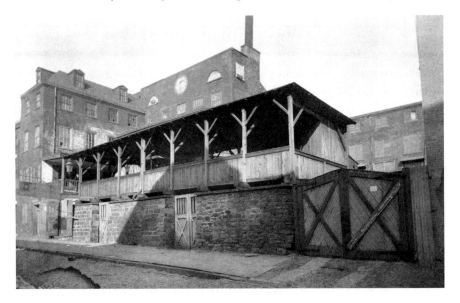

Joseph Kohnle's Bush Hill Brewery featured a summer beer garden beneath the roofed deck in the foreground. *Descendant of Joseph Kohnle's family collection.*

Wingohocking Creek near Second Street, and the other was on Fairmount Avenue above Third.

His brand was Montana Malt Beer. Kohnle had one-gallon cans made, resembling cream cans, which he filled with draught beer for off-premise consumption. The lids served as cups, and customers could get the can filled for thirty cents. Someone complained about groups of men standing around on Buttonwood Street drinking from the cans, but the superintendent of police consulted the license laws and found no irregularities.

In 1890, Kohnle bought another brewery next to his residence on Fifteenth Street above Susquehanna and modernized it. The Buttonwood plant became a retail outlet supplied by the new brewery. He started the Maltase Manufacturing Company next to the brewery. In 1896, Kohnle was cited for operating the new brewery without a license. He challenged the law, arguing that the license for the Bush Hill brewery should cover both facilities. The court noted that his application for licensing the second plant had been denied and that he needed a license for each location. He lost his license and appealed, but the decision was upheld. He eventually got a license for the second location, and both breweries continued in business until 1900.

West Philadelphia

Very few breweries were located west of the Schuylkill River, and little is known about the few that were there. In 1857, Gehring and Spunger had a brewery at Thirty-first Street and Haverford Avenue but moved the following year. Henry Gehring is listed as brewing there sometime around 1869. Charles Presser and Joseph Lubberman had a brewery at Thirty-fifth and Aspen Streets in 1860. Presser was sole proprietor in 1868, and his son continued the business from 1875 until 1888, producing fewer than five hundred barrels a year. John Lips was listed as having a brewery at Thirty-third on the west bank of the Schuylkill in 1868. Daniel Kraus had a brewery on Thirty-fifth below Wallace from 1874 until 1877. During the same period, Christian Siebolt had a brewery at Forty-fourth Street and Lancaster Avenue.

Robert Smith India Pale Ale Brewing Company

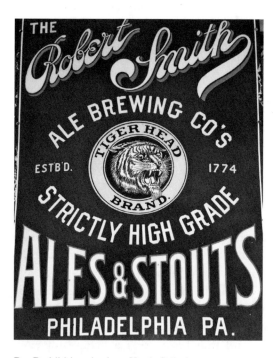

Pre-Prohibition tin sign. *Handy Collection.*

Otto Wolf designed a modern brewery for Robert Smith in 1888 at the southeast corner of Thirty-eighth and Girard. The plant had a capacity to brew 100,000 barrels a year and had two kettles, one 200-barrel and one 100-barrel. Next to the brewery was a four-story bottling house capable of doing 125,000 bottles a day. In 1891, the eighty-nine-year-old Mr. Smith was described as being "hale and hearty" and active in supervising the business. The following year, the firm began producing "Malt Hopine," a medicinal preparation made with malt and hops.

Mr. Smith died in 1893, and three years later, the brewery became a branch of C. Schmidt and Sons. They changed the name to the Robert Smith

A Heady History of Brewing in the Cradle of Liberty

Ale Brewing Company and expanded the product line. The company was well known for its Tiger Head Brand India Pale Ale. Otto Wolf completed a number of additional alterations to the plant, including the installation of refrigeration equipment and a new ale cellar. Production was over fifty thousand barrels a year. In 1908, the Schemm brewery became a branch of Robert Smith, adding another fifty thousand barrels of production. It made improvements to the Schemm brewery but closed the branch in 1917 due to war rationing.

Chapter 5
Prohibition

In the first thirty years after the introduction of lager beer, there were over 250 breweries that started up in Philadelphia. On average, about a third of these only lasted a year or two, and many more lasted less than a decade. The 1880s saw 44 new breweries in the city, but from the 1890s until Prohibition, there were virtually no new breweries. The days of small neighborhood brewery saloons that produced five hundred to one thousand barrels a year were over. During the first two decades of the twentieth century, over 30 breweries went out of business in the city. Technological advances favored production by fewer large brewers rather than a large number of small producers.

Both in Philadelphia and nationwide, brewers had invested a great deal of capital in plants and equipment, and the Prohibition movement was threatening to put them out of business. In an effort to influence public opinion, the United States Brewers Association published a book entitled *A Textbook of True Temperance* as early as 1909, outlining the industry's contribution to the national economy as well as the societal benefits of malt liquors over distilled spirits. It gave a historical perspective on the importance of malt liquor and outlined the efforts made by the founding fathers to promote its manufacture. Using census data, the book showed per capita consumption of malt liquors for various countries, as well as the tremendous increase in production of lager beer in the United States. It showed that brewery workers were the highest-paid workers of all the leading industries in the nation and outlined all the aspects of commerce that brewers contributed to,

WHY PROHIBITION?
WHY SHOULD YOU AND I AND MILLIONS
OF OTHER LAW ABIDING CITIZENS BE
DEPRIVED OF OUR GLASS OF BEER?
ASK YOUR LEGISLATORS!

Continental Brewing Company produced a series of neck labels urging customers to fight Prohibition. *Author's collection.*

from agriculture to manufacturing, construction, transportation and other industries. Finally, the book showed the amount of taxes paid to the Federal Treasury. Throughout the industry, brewers thought they would be exempt from prohibition since they did not consider their product to be intoxicating in the same way as distilled spirits. At the very least, they hoped to be able to sell 2.75 percent beer if national prohibition became law.

In August 1917, Congress passed the Eighteenth Amendment, which prohibited the sale and transportation of intoxicating liquors, or their importation or exportation, for beverage purposes. It was submitted to the states for ratification, which took two more years. With the entry of the United States into World War I, restrictions on the use of coal and grain were the first effects felt by brewers. They had to cut production 30 percent from the previous year and pay more for materials. "War beer" had an alcoholic strength of 2.75 percent alcohol.

In September 1918, it was announced that all breweries would be required to cease production December 1, and brewers would be prohibited from purchasing unmalted grains for making beer. The order also applied to near beer. Beer produced prior to that time could still be sold. The government explained that the measures were due to increased war strain on fuel, transportation and labor and reduction of agricultural products due to a drought in the West. The *Public Ledger* reported that the thirty-five to forty breweries in the city employed around one thousand men who stood to lose their jobs. Brewers could sell ice, yeast for baking, mill grain or rent cold storage space. These activities were considered essential to the war effort. The city's brewers assured the populace that they had at least a six-month supply of beer on hand. Regardless, beer sales in Philadelphia were only 15 percent of what they had been in 1915.

With the ratification of the Eighteenth Amendment in January 1919, the brewers stepped up efforts to have 2.75 percent beer designated as

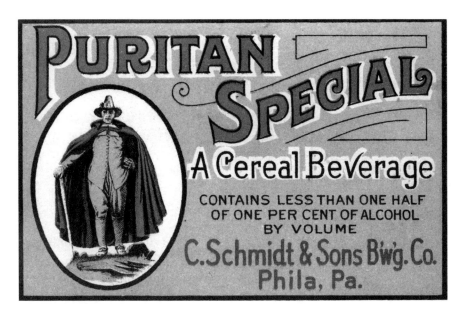

Handy Collection.

nonintoxicating and were preparing to challenge the constitutionality of the Eighteenth Amendment in the Supreme Court. The Wartime Prohibition Act prohibiting the sale of intoxicating drinks went into effect on July 1.

In October, the enforcement arm of the Eighteenth Amendment, the Volstead Act, was passed, which defined intoxicating liquor as containing more than one half of 1 percent alcohol. In January 1920, Prohibition became law, which prohibited the manufacture, sale, transportation and/or consumption of any beverage exceeding one half of 1 percent alcohol. Near beer was to be called cereal beverage on labels. In June, the Supreme Court upheld both the Eighteenth Amendment and the Volstead Act. Many returning veterans who had enjoyed moderate consumption of wine in Europe during the war were outraged at coming home to Prohibition, and it was said some immigrants actually returned to their home countries in response to the new law.

What ensued was a shell game, guessing which barrel contained the real beer, as well as a game of cat-and-mouse and, in some cases, "spy versus spy." Prohibition was such an unprecedented situation that its enforcement had to be accomplished through trial and error. An examination of court decisions shows that what was legal was being determined case by case. A huge gray area existed since brewers had to make real beer and then

remove the alcohol to make near beer. Cereal beverage permits authorized brewers to possess real beer. It was only when it was placed in kegs and delivered elsewhere that it became illegal. But there were instances where overzealous agents raided breweries and began draining "high-powered" beer that was aging.

After beer was de-alcoholized, the extracted alcohol could legally be sold to companies with industrial alcohol permits. One way that "high-powered" beer made it to the public was through the reintroduction of alcohol to near beer. Bootleggers would acquire industrial alcohol or illegally manufactured alcohol and use horse syringes to inject it through the bung of a barrel of near beer. The resulting product was called "needle beer," and it never tasted quite the same as regular beer.

Another factor that complicated enforcement was the fact that Prohibition was a federal law. It was an unpopular one at that, with politicians being branded as "wet" or "dry" and judges holding their own opinions on what the letter of the law should be. There were often differences of opinion between federal, state and local law enforcement officials. In some cases, local police had to spy on each other, as in the case of Public Safety Director Butler's "mystery squad." Other times local police hindered the efforts of federal enforcement agents to protect brewers.

Many brewers simply closed or sold their properties. This was how some bootleggers got into the brewing business. Others hoped it was only a matter of time before beer came back and tried to remain in business. Legal alternatives included near beer, for which there never was much of a market. Some brewers produced soda. There was, after all, a big demand for ginger ale to mix with illicit booze. They could rent cold storage space or sell ice and coal. The most profitable product, however, was "high-powered" beer, and practically every brewery in the city had some brush with the law. Hornung may be the only brewery in the city that remained clear of any dry violations. It sold near beer and remained in business legally for the duration of Prohibition.

Most of the accounts of law breaking involved the various methods used to ship "high-powered" beer directly from the breweries. Surveillance was used, and in some cases, it was the local police who were protecting the breweries from the prying eyes of federal agents. Sometimes brewers would send a truck containing barrels of water out the front gate and, when the coast was clear, send a truckload of beer from another entrance. There were various accounts of tunnels connecting breweries to buildings off-site. In one case, there was a false brick wall that served as a doorway

to a garage. Trucks bearing the names of laundries, dairies and other companies were pressed into service as camouflaged vehicles. Many raids involved agents discovering beer on loading docks or in brewery yards. Samples would be taken and analyzed, and the beer would be seized. However, on more than one occasion, confiscated beer would disappear from impoundment lots or from police station yards. Other times, "high-powered" beer would mysteriously become near beer over night. And unless a rail car was seized as it was leaving a brewery, it was anyone's guess where the real beer on board came from.

When their plants and property were threatened, brewers took the battle to court. In some cases, they argued that suspending their operations would cause beer to spoil and create a financial hardship for them. Beer waiting to be de-alcoholized was perishable and had to be kept refrigerated. One brewer told authorities that if it shut down the power plant and lost refrigeration, all the tanks would burst, causing the entire brewery to explode into smithereens. The fact that beer needed to be aged meant that breweries could legally have entire cellars full of real beer at any given time.

One of the early strategies adopted by the government was to cite brewers for failing to pay federal tax on illegal beer rather than for selling it. In

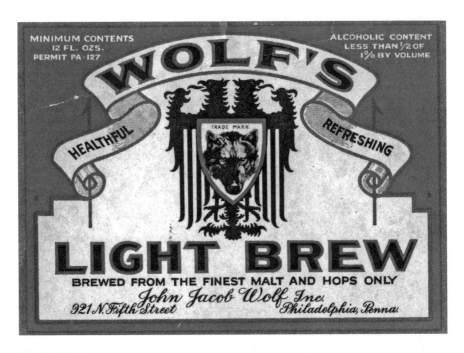

Handy Collection.

February 1921, the Betz brewery was seized for not paying a six-dollar tax on real beer it was selling. In March, the federal government ordered ten more Philadelphia breweries closed and placed under guard. These breweries were Philadelphia, American, Class & Nachod, Prospect, Finkenauer, Wolf, Roehm, Hohenadel, Weger Brothers and Bergner & Engel. A newspaper account said the raids came as a surprise to the brewers.

These actions were taken at a time when a debate was being held in Congress to determine if alcohol could be sold for medicinal purposes. The government actually began issuing permits for brewers to produce medicinal beer, but it was ultimately decided that all alcohol sales were illegal. The raids and padlocking of plants were followed by lengthy court battles, during which many brewers were cited for selling "high-powered" beer. Finally, in 1928, Bergner & Engel declared bankruptcy. As the biggest brewer, it had been made an example of after continuing to violate the dry law—900,000 gallons of beer that had turned sour during its last court battle went down the sewer. As one policeman participating in the destruction of the beer observed, Bergner & Engel's was the best beer in the city.

Forecast: Wet

One writer of the day lamented that it wasn't so much that people wanted beer but that they felt the government had taken away one of their inalienable rights. Public sentiment against Prohibition began to rise, particularly after the stock market crash of 1929. Organizations in favor of repeal began publishing literature showing how much Prohibition was costing the country, not only from lost revenue in taxes, but also the associated cost of enforcement and crime. In January 1931, the Wickersham Commission published a report that showed two of its eleven commissioners were for immediate repeal of the Eighteenth Amendment, seven were in favor of revision and only two were in favor of its retention. In 1932, the Republican Convention adopted a half-wet, half-dry plank, and the Democratic Convention adopted a plank calling for immediate repeal and revision of the Volstead Act to permit the manufacture and sale of beer. Democratic presidential candidate Franklin Delano Roosevelt was elected in November by a wide margin. The first wet victory in Congress in fifteen years came in December when the House adopted the Collier Bill, which modified the Volstead Act to legalize 3.2 percent beer. And in February 1933, the Senate

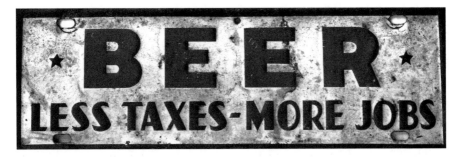

Cartin Collection.

and House voted to submit repeal of the Eighteenth Amendment to state conventions. In March, President Roosevelt recommended to Congress that it immediately pass legislation to legalize beer and other beverages, which would provide much-needed tax revenue for the government. The same month, Congress passed the Cullen Bill permitting 3.2 percent beer. After the president signed the bill, it became effective as of April 7, 1933.

It is not difficult to imagine the excitement of the wet portion of the populace when the prospect of repeal seemed imminent. In August 1932, word leaked out that the Philadelphia Beverage Company (formerly Philadelphia Brewing Company, then New Philadelphia Brewing Company) had just completed negotiations with Wall Street bankers to get financing to make expansions and improvements to its plant. An official confirmed reports that the company was planning to spend $500,000 to remodel the plant. He went on to say the plant was running at 10 percent of its capacity and employing seventy-five men in manufacturing cereal beverages. They were going ahead in the belief that the law would be changed to make beer legal, at which time two hundred to three hundred men would be employed. The company would be capitalized through a public offering of 400,000 shares listed on the New York Curb Exchange.

In September, a reporter for the *Evening Bulletin* polled local brewers on what they thought the strength of repeal beer should be. The owner of Esslinger's said it should be up to the brewers themselves, adding that 2.75 percent beer during wartime prohibition was good and comparable to the strength of the best beer made in Germany. He said beer didn't have to contain a lot of alcohol to have value. People wanted beer as a food and a medium of good fellowship, not an intoxicant. The manager at Trainer's agreed, but at the Ortlieb brewery, they felt 3.5 percent to 4 percent beer would lead to a healthy and happy nation. But all of the brewers polled agreed that the minute the law was changed, they could deliver the goods.

The capacities of some of the brewers he spoke with were: Schmidt, 500,000 barrels; Philadelphia Brewing and Scheidt in Norristown, 300,000 barrels; Ortleib, 100,000; and Trainer, 80,000 barrels. If all the breweries preparing to open were included, the total capacity would be 3,300,000 barrels a year. One headline proclaimed, "1,500,000 Gallons of Beer Waiting" as the amount of beer being held by thirty-five brewers with permits in southeast Pennsylvania and New Jersey.

The Class and Nachod brewery was purchased for $1 million, with half that amount being spent to modernize the plant. There was a crew of thirty-five men, and plans were to have a capacity to produce over one thousand barrels per day. The new owner hired the brewery's former brewmaster and envisioned three hundred jobs for brewery workers, delivery, sales and office staff. The new company planned to purchase a fleet of thirty trucks. Gus Bergner, who was then mayor of Avalon, New Jersey, was elected president and Adolph Class vice-president.

The general manager at Hornung said employment at the plant would double as soon as beer became legal, and there were plans to spend $200,000 on equipment, including a fleet of trucks and advertising. He said within six months after repeal, nearly $100,000 would be spent in construction projects that would double the capacity of the brewery, enabling it to produce five hundred barrels a day. He emphasized that changes in advertising and merchandising would be the key to success after repeal.

On March 14, 1933, a *Public Ledger* headline read "Vats Ready for Word to Yield 7,000,000,000 Glasses of Beer." Federal inspectors were busy taking samples of the beer to make sure it contained no more than 3.2 percent alcohol by weight.

There was a big sign atop the Poth brewery that read "BEER IS COMING BACK" in large letters. *Evening Bulletin* reporter Laura Lee interviewed Fred J. Poth at his old desk looking at catalogues for modern bottling and labeling machines. He said with new methods, the lager that used to age for six months could be ready in three weeks, and the catalogues advertised machines capable of filling one thousand bottles a minute. He said a one-unit machine could do the work formerly done by a building full of men and machines. His plant, which covered four city blocks, could be replaced with one half the size with the new technology.

Lee reported that the happiest person she interviewed was Edward A. Schmidt, who exclaimed, "This is a wonderful thing the president has done, I've always been Republican, but I'm for Roosevelt now!" But the general manager at the Betz brewery, who was receiving phone calls at the rate of

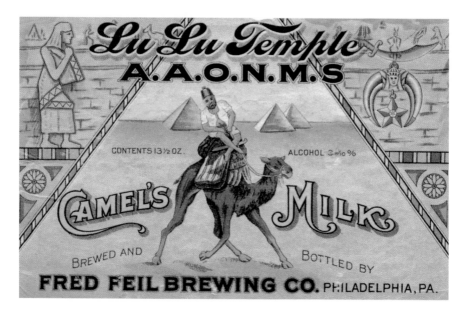

Rare private label. *Handy Collection.*

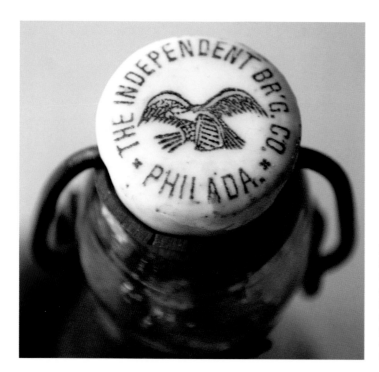

Prior to the invention of the crown cap in 1891, there were many different patented bottle closures. *Cartin Collection.*

Opened in 1996, Manayunk Brewery and Restaurant is Philadelphia's longest continuously operating brewpub. *Author's collection.*

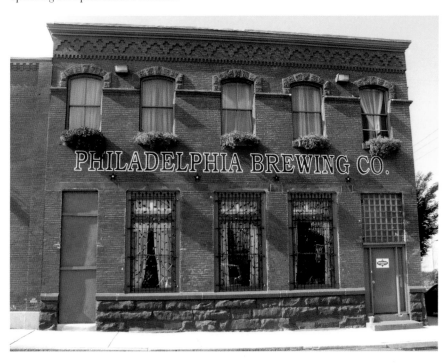

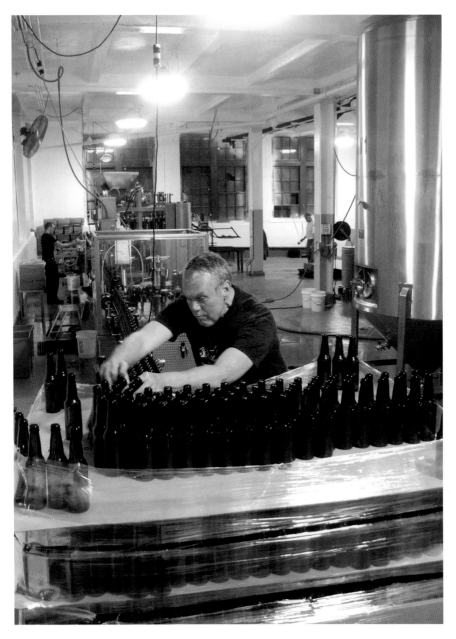

Bob Boileau loads empty bottles to be filled on Philadelphia Brewing Company's packaging line. *Author's collection.*

Previous page, bottom: The office and retail store of the Philadelphia Brewing Company is located in the oldest remaining building of the Weisbrod and Hess brewery complex. *Author's collection.*

Above: Brewer Franklin Winslow at the lauter tun in Yards Brewery's fifty-barrel brew house. *Author's collection.*

Left: Louis Bergdoll featured his portrait in print advertising and steins. *Ball Collection.*

Opposite, top: Advertising chromolithograph by Charles Tholey, circa 1873. Note Gustavus Bergner standing in front of the office. *The Library Company of Philadelphia.*

Opposite, bottom: Lithograph "drawn from nature on stone" by Augustus Kollner, circa 1855. Note the horse-drawn rail wagon loaded with beer leaving the entrance to the vaults. *The Library Company of Philadelphia.*

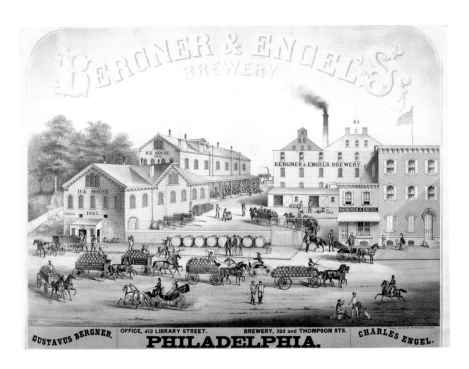

BERGNER & ENGEL'S BREWERY

ICE HOUSE 1851

ICE HOUSE 1865

BERGNER & ENGEL'S BREWERY.

BERGNER & ENGEL

GUSTAVUS BERGNER. | OFFICE, 412 LIBRARY STREET. | BREWERY, 32d and THOMPSON STS. | CHARLES ENGEL.

PHILADELPHIA.

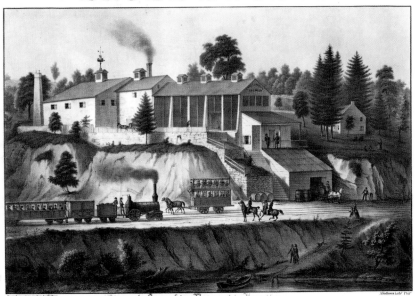

ENGEL & WOLF'S

Die erste Lagerbier-Brauerei in America.

BREWERY & VAULTS

AT FOUNTAIN GREEN

Office
N° 26 & 28 Dillwyn St
between Vine &

Callowhill &
Third & Fourth Str
Philadelphia

Including five large Vaults containing 50352 cubic feet cut out of the solid rock and about 45 feet below ground, where they keep their well known LAGER BEER
Temperature of the Vaults in midsummer 46 degrees of Fahrenheit. They are situated on the Columbia Rail Road, about one mile above the Fairmount Waterworks, Philadelphia.

Left: Point of purchase display featuring Erlanger cone top cans. *Cartin Collection.*

Below: View of the fermenting cellars of the Poth Brewery. *Handy Collection.*

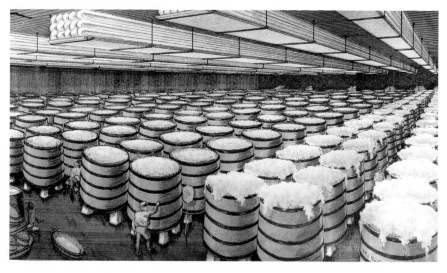

Opposite, top: Hornung's trademarked "White Bock" for which their flagship brand was named. *Fink Collection.*

Opposite, bottom: After boiling, wort was pumped upstairs from the brew house to surface coolers where it gave up its heat to the atmosphere. Slatted windows permitted steam to escape as it cooled. Schweitzer and Grim's brewery was located at Eleventh Street and Columbia Avenue from 1862 to 1875. *Print and Picture Collection, Free Library of Philadelphia.*

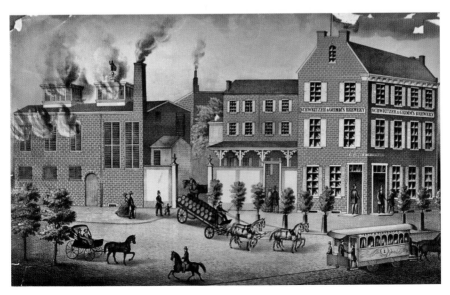

Above: This commemorative tray for the Philadelphia Beer Drivers Union is printed in German, the primary language for many associated with the brewing industry in the nineteenth century. *Author's collection.*

Left: Colorful brewery lithograhs were given to saloons. *Cartin Collection.*

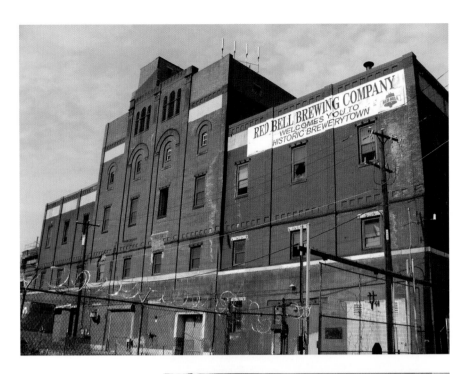

Above: Poth Brewery was reincarnated as the Red Bell Brewing Company from 1996 to 2002. *Author's collection.*

Right: Colorful banners have become advertising tools for today's craft brewers. *Author's collection.*

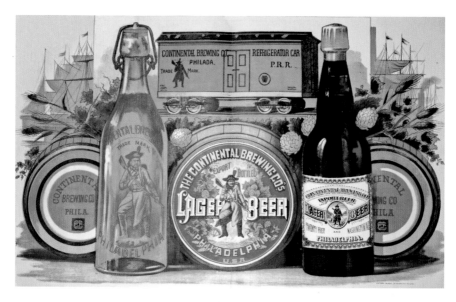

This colorful centerfold was among several illustrations in a booklet published in both English and Spanish by the Continental Brewing Company. *Handy Collection.*

This animated, lighted sign featured Esslinger's Little Man. *Handy Collection.*

The Robert Smith Ale Brewery closed in 1920, but Schmidt's continued to produce the Tiger Head brand until it closed in 1987. *Handy Collection.*

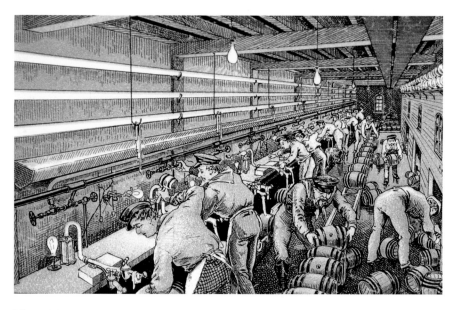

View of Bergner & Engel's racking room, circa 1887. *Handy Collection.*

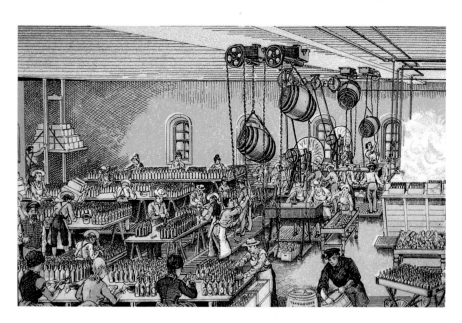

Interior view of Bergner & Engel's bottling department. *Handy Collection.*

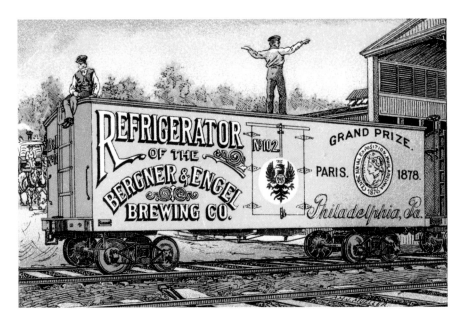

Bergner & Engel railcars were refrigerated with ice. *Handy Collection.*

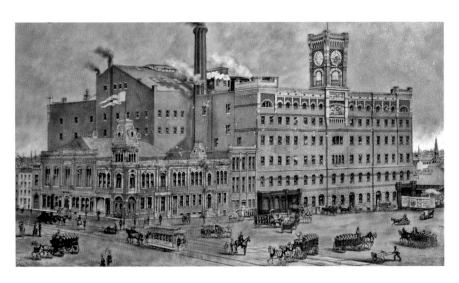

Rare tin sign issued by the John F. Betz brewery. *Handy Collection.*

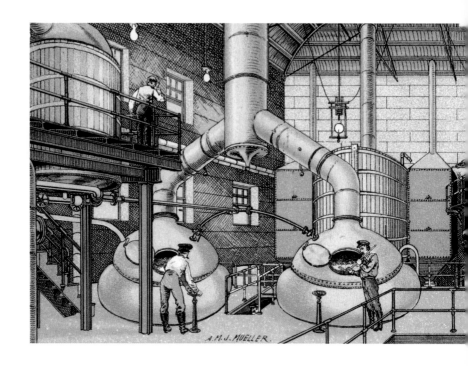

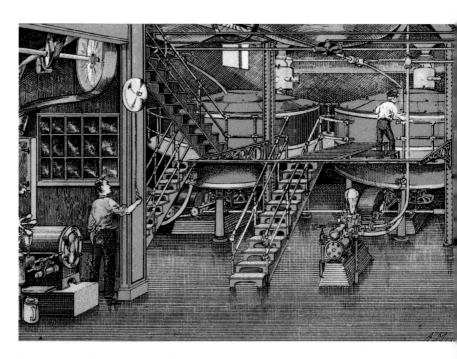

Interior view of Bergner & Engel's brew house. *Handy Collection.*

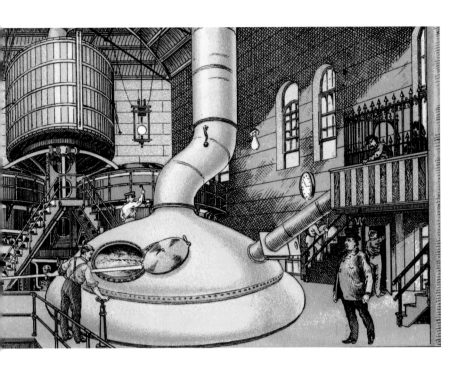

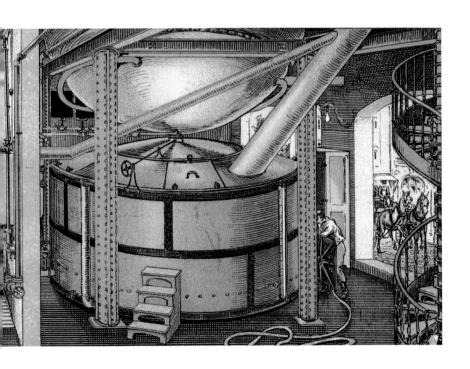

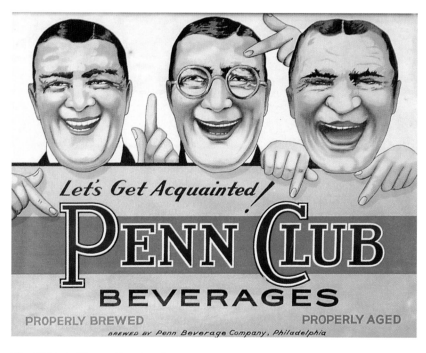

The Welde & Thomas Brewing Company was known for its Penn beer brand. The name was changed to Penn Club during Prohibition. *Van Wieren Collection.*

In January 2012, owners Kevin Finn (left) and Mark Edelson celebrated the opening of Iron Hill Brewery and Restaurant's ninth location in Chestnut Hill along with Philadelphia council member Cindy Bass at their "First Pour" event. *Author's collection.*

one every three minutes, replied to all, "Wait until you see the smoke coming out of the chimney, then come and see me." He lamented that the ranks of unemployed workers didn't have money to buy beer even if he made it.

When she visited the Esslinger brewery, Lee reported that officials of the firm were happy but hardly knew what to do first. She was told the two $20,000 de-alcoholizing machines would soon be worth about a dime.

As the repeal of Prohibition became imminent, there was a scramble on both the federal and state level to determine the rules of the game. Many changes were required as governments on all levels were basically starting from scratch. The tax on beer, licensing of retailers and the details of exactly how beer would be sold all needed to be determined. In Harrisburg, a new system establishing the cost of retail licenses, as well as the laws governing them, had yet to be decided a week prior to repeal.

With respect to taxes, a Hornung spokesman said brewers had three "friendly enemies," in the federal, state and local governments, all of whom were hoping the return of beer would replenish their depleted coffers. He said excessive taxation would "kill the beer-goose that lays the golden egg" and reminded legislators that "the law of diminishing returns grinds on inexorably." If taxes were too high and manufacturing beer was not profitable, there would be a boomerang effect for both the state and the industry, along with the prospect of a return to bootlegging. His opinion was that the state tax should be no more than $1 on top of the $5 federal tax on a barrel of beer.

On the eve of repeal, the state Senate did not approve the regulatory bill as to how retail establishments would be licensed. Without any direction from Harrisburg, the city council drafted an ordinance for licensing distributors, hotels and restaurants but was unable to pass it. The collector of internal revenue was inundated with license-seekers. On April 6, all Philadelphia police were ordered to report for duty at 10:00 p.m. to make sure no illegal beer was consumed before midnight and to keep order when the floodgates were opened. All but one brewery was planning to begin deliveries at 12:01 a.m.

For hours before midnight, hundreds of people appeared at city breweries to give legalized beer its unofficial send-off. They were deluged by rain, hail, thunder and lightning minutes before the stroke of midnight. Police had been guarding beer on the loading docks to see that it did not leave before midnight, and federal agents were on hand to make sure each barrel had a government tax stamp. The rain didn't dampen people's spirits as they cheered what one reporter dubbed "the midnight ride of legal beer."

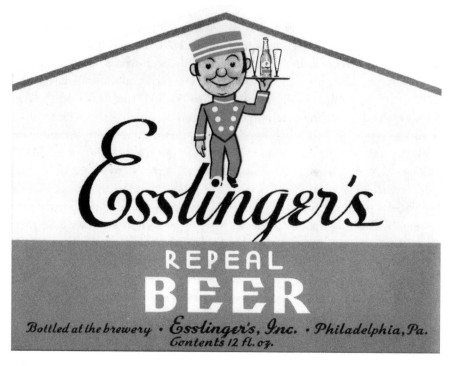

Repeal beer was 3.2 percent alcohol by weight. *Handy Collection.*

The Esslinger brewery was sending its first five cases by plane to President Roosevelt. The brewery had fifty thousand cases of King Pin Pilsner and Dark ready to go. There were one hundred trucks lined up for three blocks waiting to pick up beer. The Trainer brewery was in the old Consumers south plant. State senator and city councilman Joseph C. Trainer, who was also president of the Pennsylvania State Brewers Association, helped load the first truck. A neighborhood band played as ten thousand cases and one thousand barrels of Trainer's Light Lager flew out the door.

At Schmidt's, the crowd swelled to one thousand people. When someone noticed an open door to the office, a hundred people ran through and swarmed into a storage room containing five hundred half-barrels of beer, many walking on top of them, defacing the government stamps required for shipment. The crowd outside engulfed the first truck and moved onto the loading platform. A squad of police had to ease the crowd out of the brewery and off the loading dock so that kegs could be loaded onto the truck. Finally, the truck made its way through the crowd and was on its way up Girard Avenue hauling cold beer for the thirsty with a bottle opener

in every case. Twenty trucks, each loaded with 100 to 250 cases of Wolf's Light, Dark and Porter, were shipped that night. Hornung's brewery sent fifty trucks out with 30,000 cases of White Bock Light, Dark and Porter. The Cooper Supply Company, located in the Poth Brewery, was the local Anheuser-Busch distributor and had orders for 10,000 cases of Budweiser.

Inside the bars and cafes, bands were playing "Roll Out the Barrel" and "Happy Days Are Here Again," and the consensus among patrons seemed to be that it wasn't so much about the beer, but rather the fact that you could order one without whispering. Those waiting for the first shipment to arrive said they had already waited thirteen years and could wait a little longer. Many complained the beer wasn't cold enough. There wasn't a nickel beer to be had, and most beer was selling for ten to fifteen cents a glass. But the majority of customers smacked their lips and pronounced the 3.2 percent beer as good as before Prohibition. As the beer ran out, many bars switched to serving near beer to unsuspecting patrons.

Brewers struggled to meet demand, and those who hadn't been ready on April 7 scrambled to get permits and financing. In July, the Gruenwald family, which had operated the Premier brewery, announced they were building a new brewery on American Street above Susquehanna. Weisbrod and Hess rolled out its first product in July but reorganized a month later. The Vollmer brewery got its permit in August and started reconditioning its plant

On the eve of the repeal of the Eighteenth Amendment by the states, Gus Bergner reflected on the future of beer in America. He said all the talk about alcoholic content was a result of Prohibition. The young generation, which didn't like 3.2 percent beer because it didn't have a "kick," was used to bootleg whiskey and bathtub gin. He recalled that before Prohibition, beer was regarded as a delicious, palatable beverage, something to be enjoyed with food and good conversation. Bergner said the government should spell out what beer should contain and how it should be produced. He said beer should be regulated by the Pure Food Act and not considered to be an intoxicant, adding: "The people, and no one else, have brought beer back. It is up to us to please the people and not violate the confidence they have placed in us. If we don't follow that plan, the tide will turn again and we will be put out of business."

Brewers began storing "high power" beer, most ranging from 3.7 to 4 percent, and on December 6, the minute Utah became the thirty-sixth state to ratify the Twenty-first Amendment, they began selling it.

Chapter 6
After Repeal

As glad as brewers were to be back in business, the years after repeal presented them with many new challenges. There were many technological and societal changes that had taken place during the thirteen years of Prohibition. When beer came back, there were around 700 breweries in the nation and Pennsylvania had 112, more than any other state. Of all the state's breweries, Schmidt's production capability was exceeded only by the Duquesne Brewing Company of Pittsburgh. Consumption of beer was half of what it had been prior to Prohibition, and 75 percent of beer sold was draught.

One of the main advances was the isolation of an enzyme that could greatly reduce the time it took to age beer. The traditional kraeusening technique of adding new beer to develop carbonation created a secondary fermentation requiring considerable time for yeast to settle and clarify the beer. The enzyme could accomplish the same effect on flavor without clouding the beer. There were also improved porcelain carbonating stones, which speeded up that process. Both of these innovations greatly reduced the storage capacity required by breweries since tanks could be turned over in a fraction of the time it previously took. Combined with new architectural innovations, brewers could reduce costs by a third.

Many breweries that reorganized went bankrupt within a few years. In Philadelphia, seventeen brewers came back after repeal. Both Bergdoll and Straubmuller announced that they were spending money to modernize their plants but neither produced beer after repeal.

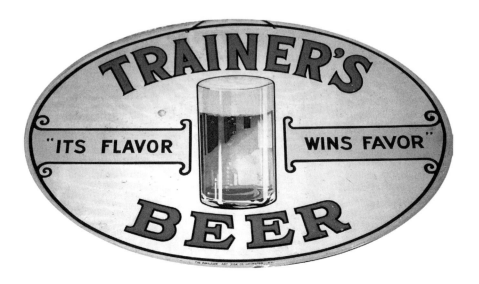

Handy Collection.

The Trainer Brewing Company started up in the old Consumers south and north plants. The south plant, formerly Welde and Thomas, had been the main branch of Consumers, and the company built a new bottling house and began work on a new brew house that was never finished. Joseph C. Trainer had been president of the Premier Brewing Company in the north plant during Prohibition. The company used it for brewing draught beer until it closed the south plant and moved all operations there in 1937.

In 1934, Hornung's White Bock Beer won first prize in a contest sponsored by the New Jersey Licensed Beverage Association. Elizabeth Hornung was touted as being the only female brewery owner in the country. They introduced "Pilsner Brew by Hornung" in response to the demand for lighter beer. They also marketed Londonderry Ale.

In November 1934, Ortlieb completed a new ale department capable of producing twenty-five thousand barrels a year and introduced a new product called Ortlieb's Bock Ale. The same month, Schmidt announced the completion of its new ale cellar which could turn out ten thousand barrels per month. The Betz brewery was totally renovated and was on stream by the fall of 1934 with two new products: Betz's Indian Pale Ale and Betz's Old York Ale. The following year, it purchased the old American Theatre and used it as a bottling house but went out of business in 1936.

Handy Collection.

In October 1933, the American Can Company published an ad in *American Brewer* to confirm trade talk that it had indeed developed a beer can. To overcome the problem of beer reacting with metal, they patented the "Keglined" coating on the inside of the can. Forward-thinking brewers could see the advantages of this development. A metal can was impervious to light, an enemy of beer, and would be lighter than glass, reducing shipping costs. In addition, it would not have to be returned to the brewery. Later, a cone top can was introduced that could be sealed with crown caps so brewers could use existing bottling lines. Cans became available to brewers in 1935, and Esslinger was the first in the city to sell its beer in cans. Ultimately, a dozen Philadelphia brewers would sell beer in cans.

Owens-Corning Glass Company developed a no-deposit, no-return "stubbie" bottle to compete with the beer can. It was three inches shorter than the traditional longneck or export bottle and was later replaced by the "steinie." Schmidt's erected the "World's Largest Steinie" at the entrance to what is now known as the Ben Franklin Bridge. It measured fifty-five by twenty-two feet, was piped in red neon with a green neon label and was seen by 130,000 motorists each day.

Pennsylvania brewers had to contend with Pennsylvania's "Crown Tax" of half a cent on each bottle cap or can lid. This meant the twelve-ounce bottle was being taxed at the same rate as larger containers. Brewers said it gave out of state competitors an unfair advantage and emphasized that the state tax on a barrel of beer was already $0.24 higher than the national average of $1.00. With the Crown Tax, packaged beer was being taxed at a rate of $1.65 per barrel.

In 1936, Gretz advertised that its beer was naturally carbonated through the traditional kraeusening method and made claims about superior flavor, head retention and carbonation. They marketed half-gallon bottles of unpasteurized

Liebert & Obert became known as the Cooper Brewing Company after repeal. Nate Cooper was one of the family members with an interest in the brewery. *Handy Collection.*

draught beer. The Cooper Brewing Company marketed a similar package advertised as the "ten glass bottle" that bartenders could serve late in the evening instead of tapping a new keg.

Shortly after repeal, it was reported that the Poth brewery was completely overhauled at a cost of $250,000 with a capacity to produce 150,000 barrels per year, but the company became insolvent, and the plant was never restarted. The Gruenwald family had operated the Premier Cereal Beverage Company during Prohibition, and A.C. Gruenwald built the only new brewery in the city after repeal, spending $225,000 in construction and alterations to adapt an existing building. His company went bankrupt in 1935. Esslinger purchased it and operated it as its ale and porter brewery and introduced Little Man Ale.

That year, the Poth company reorganized as the Poth Brewing Company, with Fred J. Poth as president and A.C. Gruenwald as vice-president. They purchased the Class and Nachod brewery and put Poth Beer on the market in October. A year later, they dedicated a new bottling facility. Using the recognition of the old Bergner & Engel brand, they introduced Black Eagle Beer and acquired Betz's Old German brand.

In 1935, Esslinger began construction of a five-story modern brew house complemented by eighty-five-foot-tall malt storage silos capable of holding over ten thousand bushels. The company purchased a six-story building and a three-story engine room and put an addition on its washing and racking rooms. The

This pre-Prohibition sign was adapted for post-Prohibition use by covering over the brand originally printed on the sign (Solitaire Beer) with a new one (Black Eagle Beer). *Handy Collection.*

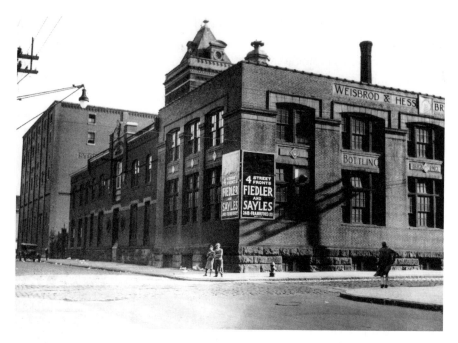

The Weisbrod and Hess Brewery came back after repeal but closed in 1939, *Philadelphia Inquirer*.

additions practically doubled its production capacity to over 300,000 barrels a year.

Hohenadel added a modern three-story brew house equipped with a four-hundred-barrel copper kettle. The project, completed by architect William F. Koelle, included a beer storage tank as tall as the brew house. Koelle did many post-Prohibition projects for Philadelphia brewers. Hohenadel produced only draught beer until 1939, when a modern packaging plant was added, capable of handling wooden and cardboard cases, pint and quart bottles and cans.

Weisbrod and Hess spent $200,000 to renovate its plant, including a new ale-fermenting cellar separated from the beer cellars. In 1933, Weisbrod and Hess went to court to prevent Brooklyn's Liebmann brewery from using the name Rheingold but lost the case. Post-Prohibition brands included Weisbrod Beer and Bock Beer, Weisbrod and Hess Pilsner and Light Lager Beer, Rheingold Lager and Pilsener Beer, Kulmbacher Beer, Certified Beer, Master Brew and Shakespeare Ale.

The Wolf brewery closed, and an auction was held in December 1937. A soda firm purchased the brew house, and the rest of the equipment was sold to scrap dealers. The following year, Weisbrod and Hess folded. The Trainer

brewery became the Otto Erlanger Brewing Company, with Fred J. Poth as plant superintendent. The company rolled out Erlanger Beer and Perone, described as the first Italian-style lager beer in America.

The 1940s

Philadelphia started the decade with eleven brewing companies in business. In 1940, Schmidt published a book with photographs illustrating its aggressive 1930s building program. The new ale fermenting and storage house was outfitted with open fermenters and storage tanks made of California redwood. Wort from the brew house was transferred to the new cellars, which were completely separate from the beer cellars. Modern packaging equipment included a can line. At this time, Crown Cork and Seal introduced the "crowntainer" steel bottle, unique because it did not have a seam at the shoulder like the cone top can. It was one of the first brewers in the country to begin using the package and dubbed it the "silver noggin," a term used for a beer stein during colonial days. They were also among the first to market beer in the newly developed "six-pack" carton that held six silver noggins. Ortlieb and Gretz followed suit and adopted the crowntainer.

In June, Ortlieb announced plans to add 200,000 barrels to its capacity. Nationally, the volume of beer packaged in bottles and cans was equal to draught beer, a first in the industry.

The seven ounce "nip" was a popular package. The name had roots back to colonial times and referred to a half pint. *Handy Collection.*

PHILADELPHIA BEER

In 1940, a one-dollar Defense Tax raised the federal tax on a barrel of beer to six dollars. Brewers throughout the nation emphasized their patriotism in advertising and by sponsoring company-wide war bond drives. The metal for beer cans and glass for no-deposit bottles was diverted to food packaging and the war effort. Quotas on crowns were instituted, which encouraged a reliance on quart bottles. By September 1942, sale of packaged beer was down, and there was a nationwide push to round up empty bottles.

In 1943, barley and malt rationing limited brewers to just over 90.0 percent of their previous year's consumption, and they could only keep 10.0 percent of that in stock at any one time. Brewers began using more rice and corn adjuncts, resulting in lighter beer, but soon table quality rice was rationed. Per capita consumption of beer reached pre-Prohibition levels, but despite increased production, there was less beer in stock at the breweries. Beer was considered an important morale booster, and 15.0 percent of production was mandated as 3.2 percent beer for military bases. Sales to taverns were cut by as much as 25.0 percent.

It was nearly impossible to buy equipment. In response to shortages of rubber and fuel, some brewers reverted to using wagons and teams for beer deliveries. Refrigerants and dispensing gases used in taverns were among other commodities that were restricted. After the war, restrictions continued on food products as America addressed food shortages in Europe.

During the postwar period, Pennsylvania doubled the state tax on beer. Many innovations in packaging were introduced, including a number of variations in the six-bottle carrier and twelve-bottle carton, which increased take-home sales for bars. Another development was the introduction of aluminum and steel barrels. Early in 1947, all restrictions were gone, and brewers were free to purchase raw materials and equipment, and the beer can and one-trip bottles returned to the shelves.

That summer, Philadelphia Brewing Company rolled out 1880 Premium Old Stock Dry Lager. It was described as being the first premium dry lager to be brewed since the war and was made exclusively with imported Czechoslovakian hops. The company filed for bankruptcy the following year.

Schmidt embarked on a postwar building program that included a new power plant, bottling house and an addition to the brew house, which added a third 750-barrel kettle. In December 1947, it became the first brewery in the city to produce a million barrels in a year. Ortlieb inaugurated an extensive postwar expansion program that included new brew and stock houses, as well as a modern "million bottle a day" packaging facility, bringing its capacity to 600,000 barrels.

Many breweries invested in new fleets of trucks after repeal. *Print and Picture Collection, Free Library of Philadelphia.*

Gretz sponsored a weekly television broadcast called *Gretz Sports Scrapbook*, with Stoney McLinn and Bill Campbell, featuring game films and interviews with sports celebrities, that quickly became a favorite in local taprooms. The brewery erected a huge animated billboard at Broad and Hunting Park featuring its trademark man on the bike with a growler in his hand. Emphasizing its "old time" theme, the man had a derby, handlebar moustache and rode a big wheel bike followed by a small dog. "Rushing the growler" referred to the pre-Prohibition custom of sending a family member to the local tavern with a small pail to be filled with draft beer for home consumption.

Hornung billed itself as "The Tastiest Beer in Town," and the firm sponsored radio and television coverage of local racetracks six days a week, featuring stride-by-stride pictures, interviews and a roundup of race results. They also introduced an innovative weekly show called *The Hornung Television Beauty Parade*, a contest open to girls eighteen years and older, married or single. Each week, five girls competed in a preliminary

round where they were judged for poise and beauty followed by evening gown and bathing suit segments. Winners were interviewed and received savings bonds. At the end of the season, two semifinalists vied for the "Miss Hornung 1948" title. Viewers mailed in ballots available through point of sale displays to elect the winner.

Franny Murray began his sixth season as the city's top-ranking sportscaster for Hohenadel's nightly broadcast on WIBG radio. Murray's experience included tenure as an all-American football player for the University of Pennsylvania, as well as three seasons with the Philadelphia Eagles. He was famous for introducing his famous play-by-play style in basketball coverage.

Cooper Brewing Company ceased brewing operations in 1949. Production of Namar Premium Beer was moved to the Flock brewery in Williamsport, and the American Company was formed, which used the Manayunk plant as a distribution point for the product. This left the city with seven brewing companies. Nationally, the number of breweries declined from around six hundred to fewer than four hundred companies in the decade.

The 1950s

In January 1950, Hohenadel announced a new advertising campaign that included regional newspapers, billboards, television spots on two networks and a seventh season of Franny Murray's radio sportscast. Later, the firm took out a year's contract with *TV Guide* magazine for a page featuring weekly sports lineup along with ads for Hohenadel Alt Pilsener.

Esslinger gave its billboard at Broad and Vine a facelift, featuring its trademarked Little Man with the message "Esslinger's, Philadelphia's Only Premium Beer." Two years later, it retooled its label for bottles and cans, retaining the trademarked Little Man but in a more stylized, modern appearance to emphasize its "Premium Beer" status. Supporting the brand were six television shows, two daily radio programs, billboards and newspaper advertising. Gretz countered by calling its beer "Extra Premium," owing to the extra time it took kraeusening its beer the old-fashioned way.

Ortlieb ran an article in the newspaper, saying it was time to "clear away the smokescreen" surrounding beer advertising, particularly the use of the term "Premium Beer" by national brands implying superiority of their products as an excuse to charge more to cover their shipping costs. The article pointed out that no one had a patent on the term "premium," and

there were many beers produced of premium quality. The article went on to say that Philadelphia was well known for quality beer when Milwaukee was little more than an Indian reservation.

Erlanger claimed a 27 percent sales increase due to its sponsorship of the *Fame and Fortune* television show and rolled out a new product called Golden Brew, said to be the result of twelve years of research. It was advertised as having a paler color, lighter body and more stability. TV commercials featured nightclub comic Buddy Lewis and announcer Gene Crane depicting "Delivery of Beer by a Stork." Unfortunately, sales were less than half of the 100,000 barrels sold in 1945, and the company went out of business in 1951.

Earlier that year, the National Production Authority reduced the supply of cans available for brewers in order to conserve tin for the war effort. Bottle manufacturers could not make up for the estimated five billion cans not being produced, resulting in an effort to round up returnable bottles and keep them in circulation. In March, beer was recognized as an essential food, so brewers were able to purchase raw materials. Restrictions on the use of copper and aluminum caused items made from those materials to become scarce. The government mandated a cessation of metal barrel production, and only repair parts were available for taps, coils and dispensing equipment. The Brewers Industrial Foundation, which had done a great deal to promote beer as a mainstay of the American diet, vigorously objected when Congress considered raising the tax on beer from eight dollars to twelve dollars a barrel.

In April, the Hornung brewery ran a newspaper ad welcoming the National League Champion Phils and Athletics back from spring training for their season openers. The copy read "Brewed in the Shadow of Shibe Park." In the fall, the company began a new campaign with the teaser line "Get Hep! Get the Beer with T.A." Further down in the ad, it was revealed that T.A. stood for "taste appeal." Local singer, composer and recording artist Al Alberts wrote the "jive-jingle" used in the commercial. The Elliot Lawrence dance band played, and the lead vocalist, Roz Patton, sang along with Alberts and his Four Aces. The new ad was aired on stations throughout the eastern states. Company president A.J. Westerman said plans were in the works for a Diamond Jubilee to celebrate seventy-five years making "The Tastiest Beer in Town" in 1954.

Schmidt's sponsored *The Mystery Hour*, which showed feature films acquired for the first showing on television. The brewery also sponsored *Who Said That?*, *Public Prosecutor*, wrestling from the Rainbow Arena and Police Athletic League boxing tournaments. The brewery made television

history by sponsoring the 1951 Mummers Parade from beginning to end, lasting nine hours and forty minutes, the longest ever continuously sponsored telecast.

In the fall of 1951, Henry T. Ortlieb and Nate Cooper purchased Barbey's brewery in Reading and changed the name to Sunshine Brewing Company. They modernized the label and, together with aggressive advertising and marketing campaigns, increased sales of Sunshine Premium Beer 50 percent in just four years.

In October, the *Gretz Cavalcade of Girls* program debuted on WFIL-TV, a live, hour-long show on Thursday nights for six weeks. During each episode, six contestants competed to be named "Gretz Golden Girl." The program included variety acts, as well as comedian Henny Youngman. Viewers mailed in their votes, and the winner became hostess of the program during the next six-week cycle. By year's end, the brewery completed an expansion program, bringing its capacity to 250,000 barrels a year, up from 100,000 barrels.

At the start of 1952, Esslinger complemented the modernization of its brewing department with improvements to the packaging department. The firm also expanded its television sponsorship to seven programs, which included John Facenda as "the voice of Esslinger" on the Channel 10 news. Detroit's Goebel brewery sued Esslinger over the use of the term "Goblet" for its seven-ounce bottle. A judge ruled in favor of Esslinger, but the firm switched the name to "Keglet." Marty Needleman was the Esslinger Little Man. Dressed in his red bellhop uniform, he represented the brewery at promotional events.

At the age of eighty-three, John Hohenadel was celebrated as being the oldest brewery executive in the city. Former Phillies pitcher Frank Hoerst joined the Hohenadel sales team. To emphasize the superiority of carbonation attained through the natural kraeusening process, the brewery launched a "Heads Win" newspaper campaign in the summer of 1953, advertising that its beer had "the creamy head that stays in the glass." This was followed by a commercial featuring a wide-eyed puppet as a European maestro conducting a group that sang a jingle to the tune of "Pop Goes the Weasel": "You've tried them all, now try the best; on tap or by the bottle, a beer a 'head' above the rest; that's Hohenadel!" The brewery was out of business by the end of the year.

Hornung redesigned its label, making it brighter and more eye-catching and featuring the slogan "Tastiest Beer in Town" and the trademark hunter's horn with the words "Dry Lager Brew." Anticipating its seventy-

fifth anniversary, the company also had gold cuff links made in the shape of the horn for salesmen and clients. It reintroduced White Bock Beer. But in September 1953, the family sold the brewery to a group of buyers, one of whom was reported to be Nate Cooper. The plant shut down just prior to the scheduled Diamond Jubilee celebration. This left Philadelphia with four breweries: Gretz, Esslinger, Ortlieb and Schmidt.

In the spring of 1953, Esslinger introduced the Parti-Quiz Pak, containing six cans in pastel colors with twenty-one different copyrighted facts printed on each. For example, "First transatlantic radio message sent 1901." People could use the facts to ask those around them questions in the same way the modern Trivial Pursuit game is played. Tavern owners said the innovative package was so popular that they couldn't keep them in stock, and the brewery began offering the cans in case lots. Nationally, home consumption of beer hit an all-time high with packaged beer accounting for around 75 percent of all beer produced, the exact opposite of the 75 percent draught being sold in 1933.

The Ortlieb brewery was a family-run business that had been named for Henry F. Ortlieb, eldest son of the founder, Trupert Ortlieb. When Henry died in the 1930s, his brother, Joe Ortlieb, took the helm. In addition to being president and treasurer, "Uncle Joe" was also managing director of the firm. On his seventy-fifth birthday in May 1954, he was overseeing the installation of a one-thousand-horsepower boiler in the brewery. The same year, the company's flagship beer won the Premium Quality Medal of Leadership at the Munich International Beer Competition, sponsored by the Internationale D'Allmentation of Brussels, Belgium.

In July, it was announced that Schmidt had purchased the Adam Scheidt brewery in Norristown and would continue to produce the Valley Forge Beer, Rams Head Ale and Prior brands there. The Norristown plant included a brew house built after Prohibition in 1938 and a modern bottling house built in 1948. The 500,000-barrel-a-year plant increased the company's capacity by 33 percent. Scheidt's Prior Preferred Beer and Prior Preferred Double Dark competed with imported beers in the luxury beer niche.

Schmidt also completed a $1 million expansion program at the main plant that included a palletization system with stackers, pallet loaders and unloaders. Other breweries, as well as distributors, adapted the innovative system. The brewery had become the state's largest and thirteenth in the nation, producing nearly two million barrels a year. Two-thirds of sales were in the Philadelphia region with a territory that included all states on the eastern seaboard, as well as Ohio.

The 1960s

Schmidt celebrated its centennial year in 1960 and made the most of it through advertising and promotions with the tag line "None Better Since 1860." The company introduced a streamlined modern label. Carl von Czoernig, great-grandson of Christian Schmidt, was president of the firm. Most of the management and board of directors were also family members. Over half of the advertising budget went toward television.

In April 1960, Esslinger launched its buccaneer-themed campaign. Chosen to appeal to both men and women, it celebrated the romance associated with pirates in literature and movies, as well as identifying Esslinger's hearty and full-bodied flavor. A redesigned label, featuring a buccaneer, as well as an extensive advertising campaign with point of sale displays, supported the rebranding effort. The company outfitted one of its salesmen in pirate regalia for personal appearances. In May, it introduced the "cold chest," a fully insulated container designed to hold six cans for up to eight hours without ice and keep them cool under the hottest weather conditions.

Esslinger's "Little Man" became a well-known advertising icon in Philadelphia. *Handy Collection.*

A Heady History of Brewing in the Cradle of Liberty

In November, Gretz released Brand-X Beer. The brewery said the name had millions of dollars of free publicity, and trial marketing exceeded its wildest expectations. They were looking forward to customers who wanted to be "Brand-X-perts." The brewery ceased operations on January 20, 1961. Esslinger purchased the brands. Sales had declined to around eighty thousand barrels, just a third of the brewery's peak in 1949.

Ray Perelman orchestrated the buyout and became president of Esslinger. The brewery began producing Gretz beer and in July announced that sales were up 25 percent over the previous summer. They purchased new delivery trucks and had plans for new equipment and expansion. In January 1964, the Jacob Ruppert brewery of New York City acquired the Esslinger, Keglet and Gretz brands. The move was aimed at bringing sales of the Ruppert brewery to the two-million-barrel mark. Robert M. Brown, former owner of the Esslinger brewery, and his sales manager formed the Esslinger Distributing Company, Inc. to sell the Esslinger and Gretz brands locally.

Schmidt purchased Schaefer's 500,000-barrel brewery in Cleveland, which brought production above 2 million barrels. This gave the company a competitive edge in Ohio, West Virginia and western regions of Pennsylvania and New York. To solidify its stand in the region, Schmidt's signed on to sponsor television coverage of the Cleveland Browns and Pittsburgh Steelers, the largest single advertising investment for the company. In 1965, Schmidt's was the fifteenth-largest brewer in the nation. Draught beer accounted for a third of production, which was twice the national average.

Vice-president in charge of production, Bill Hipp was a third-generation brewmaster at Schmidt's. In January 1965, he wrote an article for the Master Brewers Association's *Technical Quarterly* on using the computer for production planning and inventory control, a first in the industry. The following year, the company spent nearly $4 million on capital improvements of its three plants. In Philadelphia, Hipp oversaw a project that improved efficiency for filtration, kegging and packaging. He wrote an article for *Brewers Digest* that showcased the innovative forty-thousand-barrel "continuous blending cellar" with stainless steel tanks that was constructed as part of the project.

Ortlieb's introduced the "zip-top" can in the spring of 1963. The cans had an aluminum top with a convenient "pull and pour" tab and were distributed through the tri-state region. The following year, it introduced Ortlieb's Malt Liquor. The brewery sold its interest in the Sunshine Brewing Company in Reading and, in 1966, purchased the Kaier brewery in Mahanoy City. Nate Cooper became president and Henry T. Ortlieb was vice-president. They also purchased the Fuhrmann and Schmidt brewery in Shamokin that

had just undergone an extensive modernization program. Both breweries continued to make their own brands, and the Kaier plant was closed in 1968. The brewery launched its "Swinger" campaign, as in "Swing to Ortlieb's," to appeal to the young adult demographic. They were the leader in draught beer sales in Philadelphia County. On the eve of his ninetieth birthday in March 1969, "Uncle Joe" Ortlieb passed away in his sleep. He was the last surviving son of Trupert, the founder of the firm, and his nephew, Henry T., became president.

The 1970s

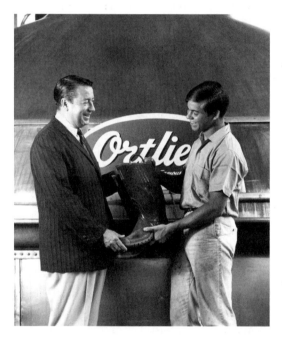

"Brewer by birth" Henry A. Ortlieb gets his first pair of brewers' boots from his father, Henry T. Ortlieb, in 1966. *Ortlieb family collection.*

Ortlieb's beer became known as the "Big O" in January 1970. The brewery sponsored commercials with ex-Eagles star and nationally known sportscaster Tom Brookshire on John Facenda's news show on WCAU-TV. A new can line was installed to keep up with demand for its popular four-pack of sixteen-ounce cans. The same year, Henry T. Ortlieb's son, Henry A., joined the firm.

In 1971, Schmidt purchased Carling's three-million-barrel Cleveland plant and moved all Ohio production there. In the spring of 1973, Schmidt purchased the brands of Pittsburgh's Duquesne Brewing Company. Duquesne had been a sales leader in the Cleveland market, and its brands included the P.O.C. label, which it acquired from the Pilsener Brewing Company in the early 1960s. The company reveled in the ambiguity of what exactly P.O.C. stood for,

A Heady History of Brewing in the Cradle of Liberty

though some variations were Pilsner of Cleveland, Pride of Cleveland or Pilsner on Call. In 1974, Schmidt tried to purchase the Rheingold brewery in Orange, New Jersey, to increase capacity and get an edge in the New York City market. This was the first year it lost money, and the Norristown plant was closed.

Members of the Schmidt family were primary stockholders in the company, and in the summer of 1975, they authorized the sale of the brewery to Heileman of LaCrosse, Wisconsin, for $16 million. Negotiations broke down, however, and the sale did not go through. Shortly thereafter, Connelly Containers made an unsuccessful bid to purchase the plant. William T. Pflaummer, Schmidt's largest wholesaler and hauler, did not want the brewery to close. In March 1976, he put a package together that included a $1 million loan from the Philadelphia Industrial Development Authority and $5 million from John Connelly, owner of Crown Cork and Seal, which supplied the plant with cans, bottles and crowns. The purchase price was reported to be $15.9 million. In order to own the brewery, his trucking company was registered in his wife's name. After the sale, the company began turning a profit.

Buying brands from struggling regional breweries was a strategy Schmidt employed to maintain production and sales. In 1976, it acquired the brands of the Reading brewery, adding 200,000 barrels in sales. The following year it acquired Erie's Koehler brands. And while the strategy to keep production up through acquisition of labels may have worked in the short term, regional loyalty frequently evaporated when production moved elsewhere.

In 1975, Ortlieb closed the Fuhrmann and Schmidt brewery in Shamokin. Henry T. Ortlieb died, and his cousin, Joseph W. Ortlieb, became president. The following year, he bought out other shareholders and became sole owner of the firm. The former president's son, Henry A. Ortlieb, developed a bicentennial can series that created quite a demand among can collectors, boosting sales as far away as New England and Chicago. Joe began referring to his flagship brand as "Joe's Beer" in television ads. He spent a great deal of money modernizing the plant.

Joe was active in the Small Brewers Association and was doing his level best to maintain position in a market that was seeing intense competition from national brands. Many small brewers saw the handwriting on the wall and knew it was only a matter of time before things came to an end. Joe bucked the trend, saying, "We'd rather fight than fold." Nationally, light beer was the sales leader. Ortlieb's Beer was 4.35 percent alcohol by weight when

most American beers were 3.75 percent. In addition, Ortlieb was contract brewing Olde English 800 Malt Liquor for Portland's Blitz-Weinhard brewery and came out with Coqui Malt Liquor, named for a Spanish word describing the sound a frog makes. The brewery also rolled out a new product called Sean O'Shaughnessy Stout. The name was selected at random from a Philadelphia phone book, and all the people named O'Shaughnessy were given a free case. Ortlieb also began producing Neuweiler Cream Ale, a brand from a defunct Allentown brewer.

In October 1977, Schmidt acquired the Rheingold brands, which added 800,000 barrels in sales. In April, Schmidt sought to purchase a controlling interest in Schaefer's five-year-old Lehigh Valley plant in Fogelsville. Schaefer responded by filing a suit under federal antitrust laws. When Schmidt continued its efforts, Schaefer attempted to impugn the reputation of "Billy" Pflaummer. Schaefer claimed his scrapes with the law would ruin the integrity of the company. In fact, Pflaummer had been fined $1,000 and given a year's probation in 1972 for selling twenty-two half-barrels of Ballantine Beer with Piel's labels, a practice he said was common at the time. His conviction on conspiracy and obstruction of justice charges stemmed from a billing system using two sets of books designed to make it appear that taverns had purchased less beer than they did to save money on taxes. He was fined $5,000 and put on probation. As far as any connections with organized crime, Pflaummer steadfastly denied those charges, saying his company could account for every cent and that he never received any subsidies from the Mafia, "whoever they are." By year's end, the court decided against Schmidt, and the brewery had to pay nearly $500,000 in legal fees to Schaefer.

Schmidt was the nation's eleventh-largest brewer. The brewery's top production in 1979 was just 8 percent of industry leader Anheuser-Busch, whose sales were 46 million barrels. Miller Brewing had been purchased by Philip Morris Inc., whose massive advertising campaigns were credited with raising Miller from its position as seventh-largest brewer up to number two, with a production of 36 million barrels. Anheuser-Busch and Miller spent $240 million in advertising, which was proving to be effective in selling premium beer at premium prices. In an effort to change its image as a blue-collar brand and attract young adults, Schmidt streamlined its label and spent nearly $3 million in advertising, which included commercials featuring local comedian David Brenner and singer Lou Rawls. Ortlieb was the fifteenth-largest brewer in the nation, producing around 300,000 barrels with an advertising budget of less than $250,000.

The 1980s

In January 1980, it was reported that Coors was considering purchasing Ortlieb's in order to open markets in the East, but nothing ever materialized. Despite the fact that Ortlieb had become profitable, Joe sold his brands to Schmidt and closed the plant in March 1981, a decision he would later say he regretted before the ink was dry on the bill of sale. He became an executive at Schmidt, and Ortlieb's was advertised as a local beer, still being brewed with the same recipe.

Schmidt made an unsolicited bid to purchase the financially ailing Pabst Brewing Company early in 1982. This astonished those in the trade. Pabst had five plants and was the nation's fifth-largest brewer with sales of 13.5 million barrels. The bid, which ultimately amounted to over $200 million, was unsuccessful, but had it materialized, it would have made Schmidt the nation's third-largest brewer. The company was only brewing at 66 percent of its capacity. That year, it rolled out Schmidt's Golden Classic and Schmidt's Select as super premium brands to compete with the nationals. Classic was supported with ads that teased, "The best you can get, if you can get it," and it was formulated to compete with the flagship brands of Anheuser-Busch and Miller. Select was designed to compete with Michelob and Pabst's Andeker all-malt brews.

Billy "the Beer Baron" Pflaumer, famous for the dark glasses he always wore due to a congenital eye defect, was a colorful character. He purchased a large property in South Jersey with a private lake, mansion, pool, golf course and tennis courts that came to be known as Beer World. Busloads of Schmidt's employees were shuttled out to enjoy company picnics. But in June 1983, after two years of investigations and court battles, Pflaumer was found guilty of evading $125,000 in state and federal taxes by underreporting fuel consumed by his trucking business. A former county judge and business associate of John Connelly who sat on the board of directors at Schmidt's declared the company was "clean as a whistle."

Pflaumer had been a person of interest for many years, and the tax evasion scheme gave the feds ammunition to charge him with a crime. He appealed his conviction, which carried a $25,000 fine and three-year sentence in federal prison. At his sentencing hearing, federal prosecutors painted him as a career criminal who employed organized crime figures in his business. But many supporters came to his defense, telling the judge that a long prison sentence could mean the end of Schmidt's. John Connelly offered to post a $1 million personal bond on Pflaumer's behalf,

telling the judge that Billy was "the hardest working person I've ever met." In explaining his client's street smarts, Pflaumer's attorney told one jury that Billy was the closest thing they'd ever see to a cross between Jimmy Cagney and Albert Einstein. Councilman-at-large Thatcher Longstreth praised Pflaumer's ability to turn the brewery around and keep it open. Others cited his contributions to charitable causes. Despite appeals that went on for three years, he was ultimately given a three-year sentence in federal prison in Lexington, Kentucky.

Schmidt closed the Cleveland plant in September 1984 and virtually stopped advertising its flagship brand. Production of Schmidt's Classic Beer dropped from 150,000 barrels to around 20,000. Distributors with long ties to the brewery blamed the lack of advertising on declining sales.

In 1985, Schmidt's produced a 125th Anniversary Sampler Case that included Schmidt's, Schmidt's Golden Classic, McSorley's Cream Ale and Prior Double Dark. It began contract brewing Newman's Albany Amber Ale for an early East Coast microbrewery. The company had a contract with Hurliman of Switzerland to produce Birell, a nonalcoholic beer made with a patented process. And there were plans on the drawing board for Schmidt's Break, a nonalcoholic beer. The company was also considering getting into the bottled water market. When interviewed, William Elliott, Schmidt president, said there had been a modest increase in sales and that the brewery was making a profit. At the time, the four largest brewers, Anheuser-Busch, Miller, Stroh and Heileman, were selling nearly 80 percent of the nation's beer.

Billy Pflaumer began serving his three-year term in federal prison in Lexington, Kentucky, in March 1986. This limited his management of the brewery to one fifteen-minute phone call per day. A year later, sales had dropped to 1.6 million barrels and employment was down to four hundred people. John Connelly feared losing $24 million in loans to the brewery. Rumors that Heileman was purchasing Schmidt's were confirmed in April, although it was buying the brands but not the property. Pflaumer was permitted a brief furlough from prison to finalize the deal, which went through when union contracts expired on June 1, 1987. Heileman moved production to its plant in Baltimore, and the fate of the fifteen-acre property at Second Street and Girard Avenue hung in the balance. It was the first time in over three hundred years that there were no breweries in the city.

Chapter 7

The Craft Brewing Renaissance

The terms "craft brewing" or "craft beer" were not in common usage until around the turn of this century. Until then, the new small breweries were called microbreweries, and their products were frequently referred to as "micro beer" or "micro brews." Their beer was made without the use of adjuncts such as corn or rice, separating them from mainstream American beers. The all-malt brews tended to be darker and hoppier than what was generally available on the market. Even the term "microbrewery" was loosely defined. At first it described breweries that produced fewer than ten thousand barrels a year, and as the segment grew, so did the designation. Today, the Association of Brewers classifies a microbrewery as one that produces fewer than fifteen thousand barrels. Craft breweries produce from fifteen thousand to six million barrels, at least half of which are all-malt products. And brewpubs are breweries that sell at least 25 percent of their beer on site.

In the early days, most of these brewers were on the West Coast and did not have the production to permit widespread distribution. Although some outlets made it their business to sell the new brands that beer aficionados clamored for, distributors in Pennsylvania for the most part were geared toward established distribution networks with national and regional breweries. It took a great deal of time before conditions were right for them to handle beer from what would become the only growth segment of the industry.

Contract Brewers

In Philadelphia, the Dock Street Brewing Company was formed in 1985 by Jeffrey Ware and a group of investors. The name harkened back to Philadelphia's earliest brewers located around Second and Walnut Streets near Dock Creek. Ware hired Mortimer Brenner, a highly respected veteran of the industry, to design Dock Street Amber Beer. The company contracted with F.X. Matt of Utica, New York, to manufacture the all-malt product, which sold for twenty-one dollars a case, on par with the price of imported beer. At the time, Schmidt was selling economy brands in returnable sixteen-ounce bottles for around five dollars a case. The new super premium all-malt brands became known as "boutique beers," and Dock Street Amber was touted as a connoisseur beverage, a perfect complement to haute cuisine. Jeffrey Ware made it his business to educate the public about beer, its ingredients and styles and emphasized that he was producing a traditional wholesome product, "like your grandfather drank." Within three weeks of its introduction, Dock Street Amber was voted "Best New Beer" at the Great American Beer Festival.

By 1988, Dock Street was selling 7,500 barrels and was available in fifteen states, with a distributor in Los Angeles. The product was seen in episodes of the popular television series *Thirtysomething*. In 1992, the company hired William Moeller III, a fourth-generation brewmaster with a long career that included stints at both Ortlieb and Schmidt breweries. He formulated Dock Street Bohemian Pilsner and Illuminator Bock.

Jim Cancro was a structural engineer who dreamed of opening a brewery with a chain of brewpubs. When he needed help developing a business plan, he contacted Jim Bell, a bonds trader with Janney Montgomery Scott in Philadelphia. The two had tended bar together at the New Jersey shore during their college days. They decided to start with a contract beer and formed the Red Bell Brewing Company in 1993. Bell suggested they bring out something like Budweiser since it was the leading national brand. Cancro said they would do no such thing and began educating Bell on beer styles. The two attended the Carnival Festival in Cologne, Germany, and that's when Bell developed an appreciation for Kölsch beer. Cancro figured if Bell liked it, Kölsch would be the perfect style to introduce mainstream American beer drinkers to the world of beer.

They contracted with the Lion, Inc. in Wilkes-Barre, and Red Bell Blonde Ale was born. During the spring of 1993, they spent $200,000 on advertising that included radio and billboards that read "Did You Have a Blonde Last Night?" and bus kiosks began displaying ads proclaiming "Philadelphia is

Putting Blondes Behind Bars." The beer was billed as "the blonde with no after-taste" and described as "pale golden in color with a subtle fruitiness and gentle hop dryness." The plan was to sell seven thousand barrels the first year.

The City's First Brewpubs

Philadelphia Brewing Company, Samuel Adams Brew House

David Mink owned the Sansom Street Oyster House, located in the shadow of city hall just above Fifteenth Street. He was a member of Homebrewers of Philadelphia and the Suburbs and was ideally suited to bring brewing back to Philadelphia. He aligned himself with Jim Koch, owner of the Boston Beer Company, which had started contract brewing in 1984. The association between the two gave the contract brewer an actual brewing location with his name on it, and it gave the brewpub owner the recognition of the Samuel Adams brand. Koch supplied the recipes, and Mink set up and operated the brewpub.

Pennsylvania changed its laws legalizing brewpubs in May 1989 with the stipulation that they could only sell beer produced on premises. The grand opening took place November 29, 1989, Samuel Adams's birthday. Upstairs from the Sansom Street Oyster House, at a hand-carved mahogany bar imported from Lancashire, England, they were pouring George Washington Porter, Ben Franklin's Golden Ale and Poor Richard's Amber Ale. A sign proclaimed that it was "Philadelphia's First Brewery Since Prohibition." Jim Koch noted that the beer traveled all of five feet from the brewery to the taps, while David Mink extolled the importance of freshness. Local home-brewer turned pro Jim Pericles beamed with pride and received accolades for his ales.

A few years later Pericles went to work for Koch up in Boston, and William Reed took over as brewer. His most ambitious undertaking was Brew House Tripel Bock, which he introduced in 1994. It was aged in whiskey barrels for four months and had 17 percent alcohol by volume. Triple Bock won a Gold Medal at the GABF in 1997 in the Other Strong Ales category. He began serving cask-conditioned IPA and mild as regular beers drawn by a hand pump and continued to offer a wide variety of specialty beers, many unfiltered. In 1996, he created a dry beer/cider hybrid made with locally grown apples. After a successful ten-year run, David Mink closed the city's first brewpub on May 1, 1999.

Dock Street Brewery and Restaurant

With the success of the Dock Street brand, Ware undertook a $2 million project to create a brewpub at Eighteenth and Cherry Streets. He hired Will Kemper, a chemical engineer who had started the Thomas Kemper Brewing Company in Washington State, to set up the brewery, which included an eight-barrel JV Northwest system. One major difference between Dock Street and the nearby Samuel Adams Brew House was that Ware's brewery would be the city's first "full mash" brewery, making beer from scratch instead of malt extract. The brewery would also be brewing lagers as well as ales. A gala opening was held in October 1990 with a host of local celebrities and over two hundred guests. Ironically, the brewpub law excluded Dock Street Amber from being sold since it was being produced in Utica.

In 1993, Nick Funnell was hired as brewer. Nick came from Britain after having worked for a company with a chain of five brewpubs. Within seven years, he was head brewer supervising brewing operations for the chain.

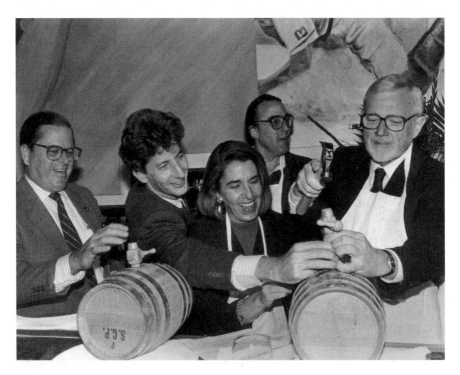

Dock Street Brewery and Restaurant's gala opening celebration in October 1990. *Left to right*: D.A. Ron Castille, Jeffrey Ware, the *Inquirer*'s Karen Heller and Clark DeLeon and William V. Donaldson, president of the Zoological Society. *Author's collection.*

Dock Street Amber became available in Paris, France, where there was a developing fascination with America's new beers.

Early in 1994, Dock Street made a stock offering in order to raise money for a planned brewpub in Washington, D.C. It acquired space in the Warner Theater building. Fennell designed the brewery and was slated to oversee operations there, but after opening early in 1996, it closed within three months.

Eric Savage replaced Nick in Philadelphia and continued Dock Street's tradition of brewing a wide variety of beer styles. In fact, it seemed the mission statement of the brewpub was to brew every style described in Michael Jackson's book, *The World Guide to Beer*. In January 1997, Eric brewed the brewery's 1,000th batch of beer. In honor of the Philadelphia Flower Show, he released a Kölsch-inspired Floral Ale made with seven different flowers. He also brewed a Belgian-style Grand Cru fermented with La Chouffe yeast and aged for two months in barrels from the Chadds Ford Winery. For fall, Savage brewed a Hop Harvest Ale made with Cascade and Willamette hops fresh from the field, grown at Chadds Ford Winery.

Around the same time, Ware sold his interest in the restaurant to his partners, and the name was changed to Dock Street Brasserie. Eric Savage began producing Savage Beers, which became the house brand. "America's Mayor," Ed Rendell, was there to celebrate the beer's debut in December. Savage beers became available to outside accounts on draught, and later, under contract with Yards, the brand became available in bottles.

Manayunk Brewery and Restaurant

The name Manayunk is a corruption of the Leni-Lenape word for "where we go to drink," or some variation on the theme. It presumably described the area where the Wissahickon Creek flowed into the Schuylkill River. In modern times, it had become a down-and-out mill town that experienced a revival in the 1980s. One of the leaders in that metamorphosis was Harry Renner IV, who, together with his father and some investors, purchased the recently closed Krook's Mill on Main Street just above Shurs Lane. The mill was on the river and had originally been water powered, located just below the outfall of the Schuylkill Canal. They spent $500,000 in renovations and in December 1993 opened the Manayunk Farmers Market. Susan Ortlieb ran a salad stand there. Her husband, Henry, was an old classmate of Renner's and was anxious to get back into the beer business. He wanted to

develop the downstairs portion of the building into a brewery and pub. He developed a business plan that included an investment of $1 million and went to work lining up distributors for his product with hopes of opening by the end of the year, in time for the 125th anniversary of the founding of his great-grandfather's brewery.

It took longer than expected to get the necessary permits, and Harry Renner ended up doing the project on his own, but late in the fall of 1996, Manayunk Brewery and Restaurant opened as the city's third brewpub. The brewery included a 15-barrel Bohemian system and 150 barrels each of fermentation and serving tank space, with seating for three hundred people. Tom Cizauskas, of Oxford Brewing Company in Maryland, was hired as brewer. One of the more notable beers in the opening lineup was Schuylkill Punch, a raspberry wheat ale made with eleven pounds of raspberries per barrel. It was named by Harry's father for the term Philadelphians used to describe their drinking water back in the day. A year after opening, Cizauskas moved on, and his assistant, Jim Brennan, became brewer.

In September 1999, the Schuylkill River overflowed its banks as a result of Hurricane Floyd, and the brewery found itself under six feet of water. The entire brewing system and any tanks that were empty floated like fishing bobbers After the water receded, the scum line on the brewing kettle was at a thirty-degree angle. The entire brewing platform, kettle and mash tun had been lifted up, water and electric lines were ruptured and the system floated. But with a great deal of work, the brewery and restaurant were up and running within six weeks, in time for a Halloween party. Despite the interruption, Manayunk produced over one hundred batches of beer that included twenty-five different beer styles that year.

Production Breweries

Independence Brewing Company

Bob Connor was a young stockbroker who was inspired by what Jim Bell was doing with the Red Bell brand. He began researching possibilities and decided on starting a brewery rather than a brewpub. With the help of ten investors and loans, he began putting his plan into motion. Bob approached Bill Moore, a brewer with five years experience at Stoudt's brewery. He offered Bill an opportunity to build a brewery and to become an officer of

the company. They found an industrial building in Northeast Philadelphia near Oxford Avenue and Langdon Street. Moore outfitted the brewery with a 40-barrel JV Northwest four-vessel brew house, 240 barrels worth of fermenting space, two 160-barrel finishing tanks and a used bottling line. Initial production was targeted at 5,000 barrels a year.

Independence Ale was delivered to selected tavern accounts in the spring of 1995. It was a British-style ale with a toffee-like, nutty malt finish, deep amber color and 4.3 percent alcohol by volume. It was bittered with Cascade hops and finished with Kent Goldings and Fuggles hops. When it debuted at the first Philadelphia Craft Brew Festival in April, the brewery touted the fact that its beer was full flavored and not pasteurized like contract brands.

Independence soon added Golden Ale and Lager to its lineup. The company started contract brewing right from the start, including a private label for Dave and Busters called Pier 19 Classic Reserve. By fall, the beer was available throughout southeastern Pennsylvania and parts of New Jersey.

In June 1996, the company's quarterly newsletter, the *Declaration*, reported there was an Independence Brewpub in Fort Lauderdale, Florida, with plans for a chain of brewpubs and restaurants. Connor and an investor from New York had purchased and reflagged the recently closed River Walk brewery. The Florida brewpub had the Independence name and logo but was run as a separate entity.

That fall, the brewery brought out Franklinfest, a lager that took a gold medal at the Great American Beer Festival in the Märzen/Oktoberfest category. Independence Golden Ale received a bronze medal in the Golden Ale/Canadian Style category.

In an effort to increase output, Independence installed a brand-new Krones bottling line and purchased an automated keg line. Early in 1997, the company went public with an IPO of 900,000 shares at $5.00 per share. It was listed on NASDAQ as IBCO. The company spent $1.5 million on advertising, including billboards, one of which ironically proclaimed, "Independence—Enjoy It While It Lasts." By spring, the stock was worth $1.50 per share.

Connor purchased additional tanks from two defunct breweries in Oregon to increase capacity to 40,000 barrels a year. Independence brewed 5,200 barrels in 1997 and planned to double output in 1998. Independence purchased the Delaware-based Blue Hen contract beer brand, as well as Gravity and Nittany Ale brands, and early in 1998, it began contract brewing three brands for Reading's Pretzel City Brewing Company. It was reported that Independence was looking into a joint venture with Capital City Brewing for a brewpub in Center City.

Yards Brewing Company

Around the same time that Independence Brewing Company was getting started, Tom Kehoe and Jon Bovit were establishing Yards Brewing Company in Manayunk. They found a tiny building on Krams Avenue just east of Wilde Street below Leverington. The two were college friends, avid home-brewers and had worked at the British Brewing Company in Glen Burnie, Maryland. With $50,000 between them, they had equipment fabricated and started with a capacity to brew 1,000 barrels a year. The 3.5-barrel kettle yielded about six kegs per batch, and they brewed four times per week. Yards products were British-style ales that were keg conditioned and dry hopped with a "hop pocket" of East Kent Goldings in every keg. The brewery's flagship brand was Yards Extra Special Ale, or ESA, which it said was a cut above the traditional ESB, or Extra Special Bitter. It also blended an Imperial Stout and a Dark Mild to produce a traditional "Entire Porter." Its distributor began importing traditional British beer engines for the bars that carried Yards, which gave the hand-drawn pints of Yards a traditional flavor. Yards ESA created quite an impression at the Philadelphia Craft Brew Festival in April 1995. By fall, the brewery added a six-barrel fermenter.

In 1997, Yards moved to a larger space on Umbria Street just above Paoli Avenue in Roxborough. The new brew house had a custom-made twenty-five-barrel stainless steel kettle that was bricked up just like the first one. This was complemented with two fifty-barrel open fermenters and two finishing tanks. It also installed a small bottling line to expand distribution. The new plant was up and running by the end of the year, and the first new draught beer released was an Irish-style ale, conditioned with nitrogen, called Brawler.

Nancy Barton came on board as marketing director in 1998, and her husband, Bill, became a salesman a year later. They bought into the company and provided some much-needed capital. Around this time, Jon Bovit moved on to other pursuits.

Gravity Brewing Company

America U-Brew opened in January 1995 as a "brew on premise" (BOP) store. Backed by a group of investors, Penn grads Michael Morrissey and Paul Konkel set up shop on Spring Garden Street just above Delaware Avenue. On premise breweries had become popular in Canada, where taxes on beer were high, and customers could save money by making their own

beer. America U-Brew was the fifth to open in the United States and the only one outside of California. By year's end, there were twenty-eight BOPs in the United States, and Morrissey and Konkel had plans to start a chain.

America U-Brew had over one hundred recipes, ingredients and all the equipment necessary for customers to brew 13.5 gallons, or six cases, of beer. The beers were brewed using malt extract with brewers on staff to guide people through the process and oversee the beer during fermentation and aging. In two weeks, the customers returned to bottle their beer. They could even design their own labels using America U-Brew computers. The cost of materials was around $100, plus $50 for labels and bottles.

In December, the company was licensed as Gravity Brewing Company and became the city's third production brewery despite the fact that its batch size was less than a keg of beer. The brewing staff could brew during times when there were no customers to maximize the efficiency of the operation. The flagship brand was Gravity Pale Ale, and the small batch size gave them the flexibility to sell specialty products that restaurants could tout as house beers.

By the spring of 1996, America U-Brew had opened stores in Chalfont and Berwyn. Soon afterward, Gravity boasted over two-dozen taps in the city. The beer was available in twenty-two-ounce bottles as well as the Gravity Pack, an ingenious home draft system. In the fall, America U-Brew announced plans to open locations in Pittsburgh, Kansas City and Texas. The Chalfont location was closed and moved to Kansas City, where it opened as Gravity Brewing Company, a combined BOP and microbrewery in May. It only lasted about six months before shutting down.

In January 1998, America U-Brew closed. The owners contracted with Yards to produce kegs and bottles of Gravity Pale Ale in order to keep it on the market and generate income. The brewery had fifty accounts in the city, some of which claimed to be selling more Gravity than Budweiser. By year's end, Independence purchased Gravity's brands.

Red Bell Brewing Company

As Red Bell got closer to opening its own brewery, it ended its contract with the Lion, Inc. in 1995 and introduced three draught products brewed by Arrowhead Brewing Company in Chambersburg and two others from Whitetail Brewing Company in York. The company purchased a portion of the Poth brewery complex in Brewerytown, which was outfitted with a

forty-barrel Century brew house with fourteen forty-barrel Unitanks and a huge bottling line from the Amstel brewery on the island of Curaçao. There were plans for a brewing museum designed to celebrate the glory days of Brewerytown and a beer hall large enough to seat 2,500 guests. There were also plans for a brewpub in the Corestates Center, a sports facility slated to replace the Spectrum at Broad and Pattison Streets.

By the spring of 1995, Bell had raised $3 million by selling private stock to about fifteen investors and tried unsuccessfully to get a public offering off the ground. He later claimed to have attracted four hundred investors, many of whom were players for Philadelphia sports teams. And while acknowledging that Independence had more capital, Bell said his company would survive an industry "shakeout," free of the constraints of being a publically owned company.

When interviewed by *Inquirer*'s Art Carey in July 1996, Bell described plans for a second brewpub and outdoor café at Broad and Chestnut Streets. But when Art asked Bell what his favorite beverage was on a hot day, Bell told him it was Juicy Juice, saying, "I'll take that any day over a beer, even a Red Bell." That response made it clear that Jim Bell was not a "beer guy" and did nothing to endear himself to local beer aficionados.

Renovations took much longer than expected. They hired Brandon Greenwood as brewer and were up and running the following summer. Greenwood was most famous for his credentials as having attended the Herriot Wall University in Edinburgh, Scotland, where he received a degree in brewing, distilling and malting science. Red Bell began producing draught Philadelphia Original Lager. Greenwood formulated Red Bell's Wee Heavy Scotch Ale, advertised as having over one hundred pounds of English, Scottish and French malts per barrel. Lemon Hill and Strawberry Mansion wheat beers were introduced as summer seasonals, named for two of the old mansions located in Fairmount Park. After getting Red Bell's brewery underway, Greenwood helped set up Yards' second brewery and became a brewer there. Jim Cancro hired Bob Barrar, who remained with Red Bell for the duration.

In 1998, Red Bell opened a pub at Philadelphia International Airport's new B-C Connector area and began work on a three-hundred-seat brewpub at the Reading Terminal Headhouse at Twelfth and Filbert Streets. The plan was to install a small brewing system that could be supplemented with beer from Red Bell's production facility. The Corestates Center became the First Union Center, and Red Bell's ten-barrel brewpub was open during games and events there.

Poor Henry's American Street Brewery

Henry A. Ortlieb left the family brewery as a young man back in the 1970s and went into commercial real estate. But even before the concept of microbreweries and brewpubs was on anyone's radar, he envisioned getting back into brewing on a small scale. Finally, at the age of forty-nine, Henry realized his dream. He invested close to $1 million of his own money along with other financing and purchased the old Ortlieb bottling house on American Street, where he planned to have a combination brewpub and production brewery. He installed two separate pub brewing systems, one seven-barrel and the other a sixty-barrel. He hired John Ruhl, a sixth-generation brewmaster whose father had been connected with the

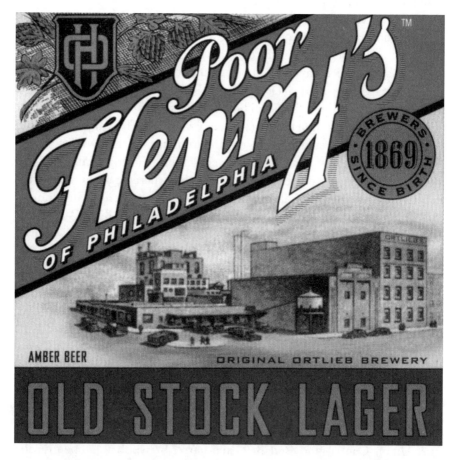

Henry A. Ortlieb adopted retro-themed labels for his production brands. *Author's collection.*

Champale brewery in Trenton, New Jersey. Bill Moeller, who had been the last brewmaster at Ortlieb's, was hired as a consultant.

Unfortunately, he couldn't use his family name. When Stroh acquired Heileman's brands, it included Ortlieb's Beer, and the price it wanted for the brand was prohibitive. The brewpub became Poor Henry's, and the production facility was flagged as Henry Ortlieb's Original Beer Works, Ltd. In June 1996, there was a gala opening, and Poor Henry's Awesome Ale, Stock Lager, Cream Ale and Porter flowed from the taps.

In spring 1998, Ortlieb acquired the Dock Street brands. It was the first time that the contract beer was being brewed in Philadelphia. He maintained the contract with F.X. Matt, which packaged Dock Street Amber in cans. In the fall, he rolled out Docktoberfest Märzen, a new addition to the lineup of packaged products. In the beginning of 1999, Ortlieb's Select Lager was introduced to compete with Yuengling Traditional Lager's dominance of the Philadelphia market. Henry was able to begin using the family name again after Stroh stopped producing the brand.

The Shakeout

While it had taken a long time for the trend to arrive, Philadelphia was home to four production breweries and as many brewpubs at the turn of this century. But nationally, industry analysts had predicted that a shakeout would leave only the strongest companies, noting that companies loaded with high debt and low sales were vulnerable. The 25 percent growth experienced in the early years that had attracted so many to the new niche had declined sharply. Poor performance of several early public stock offerings by microbreweries contributed to a decline in investors.

In the summer of 1998, a surprising story surfaced. It was reported that Pittsburgh Brewing Company was making a bid to purchase Independence Brewing Company in order to become a publicly traded company and have a position on the stock exchange. Bob Connor recognized that a merger would give Independence advantages in purchasing and distribution. Independence was losing money and was desperately trying to increase its market share. The deal would involve no money but give Pittsburgh Brewing 87 percent of Independence stock. Pittsburgh was a struggling regional brewery with excess capacity looking to increase its production. A year later, Independence had been delisted from NASDAQ, and Bob Connor had been replaced as

CEO by the company's attorney. The company was still trying to work out a deal for a Center City brewpub that was viewed as its salvation. There were attempts to get a cash infusion and reports that Independence was planning to purchase the Catamount brewery in Vermont. By the summer of 2000, the company had folded, and ironically, Moore spent his Fourth of July weekend sending Independence equipment off to Big City Brewing Company in Kingston, Jamaica.

While Independence and Pittsburgh were considering a merger, Red Bell was said to be negotiating a deal to purchase the Lion, Inc. But Lion management had their own internal offer to purchase the company, and the board declined Red Bell's offer. After talks broke off with Independence, Pittsburgh made an offer to merge with Red Bell. In this scenario, Pittsburgh would be a wholly owned subsidiary of Red Bell, with each brewery producing its own brands. Jim Bell was said to be excited about the prospect of selling a canned version of Philadelphia Original Lager. Red Bell would then make a second attempt to purchase the Lion, Inc., with plans to produce soda there. Very few people reading these reports were taking them seriously.

Red Bell became involved in a bankruptcy case over its airport pub and planned brewpub at the Reading Terminal Headhouse in Center City. Early in 2000, those properties went to Dock Street Brasserie and became Dock Street Terminal Brewpub and Dock Street Airport Pub under a joint licensing agreement with Henry Ortlieb, who was producing the Dock Street brands.

A few months later, Poor Henry's American Street Brewery was in Chapter 11 and closed at the beginning of June. Ware took Ortlieb to court to get money owed to him from the sale of the Dock Street brand. Four years later, Ware prevailed and resumed contract brewing with F.X. Matt in Utica.

Jim Bell unsuccessfully contested the case on the grounds that he had spent $2 million to develop the terminal property. His other brewpub and production brewery were still operating, and he issued a NASDAQ-registered IPO in the fall of 2000 with plans to open more brewpubs. Cancro was brewing on a part-time basis, and construction had begun on a Red Bell brewpub in Manayunk.

The Dock Street Terminal Brewpub became Independence Brewpub in the summer of 2001. The owners could not use the Dock Street name and made a deal with Bill Moore, who still held the position as president of Independence Brewing Company, for use of the name. As part of the deal, the brewpub would have three taps devoted to Independence brands, brewed by Bill at Sunnybrook Brewpub in Pottstown. Bob Connor

Ortlieb's bottling plant on American Street was brought back to life as Poor Henry's brewpub and production brewery from 1997 to 2000. *Author's collection.*

and Henry Ortlieb were working with Moore as marketers and planned to contract brew Independence brands at the Jones Brewing Company, a regional brewer in Smithton, Pennsylvania.

Tim Roberts stayed on as brewer at Independence Brewpub and continued brewing the same beers as before, adding a lineup of guest beers to supplement the beer he could produce on the ten-barrel brewing system.

In mid-2001, Dock Street Brasserie was sold to a group of investors that ultimately changed the name to Dock Street Bar and Grille, then the Mermaid Supper Club, which only remained in business a short time.

Early in 2002, Red Bell lost its brewing license over $80,000 in back taxes. The company had negative assets of nearly $5 million, and Red Bell stock was worth 3.5 cents per share. Jim Bell resigned as CEO and was replaced by Martin Spellman, a contractor who had accepted 300,000 shares of Red Bell stock for construction work he did to get the brewery started in 1995. The brewpub at the First Union Center remained open. By summer, Red Bell's building and equipment were sold. The Manayunk brewpub lay idle for two years, until it reportedly brewed a 3.5-barrel batch of California

Common early in 2004. That lasted a couple of weeks, and the brewpub closed. The brewpub at the sports center, which had been renamed the Wachovia Center, continued operating for around two years.

The Survivors

As the dust was still clearing from the shakeout, Samuel Adams, Manayunk and Red Bell at the sports complex were the only remaining brewpubs in the city. Yards emerged as the city's only surviving production brewery and was ready to expand again. Its lease in Roxborough was up in September 2001, and Yards was looking for a third location. Bill and Nancy Barton came upon the old Weisbrod and Hess brewery complex and liked the idea of resuscitating an old brewery.

The company got some investors, purchased the property and spent $500,000 renovating the complex, which included two stable buildings, the office and the bottling house. They set up the brew house on the second floor of the bottling house. The system included a new twenty-five-barrel kettle, and the old one was used as a hot liquor tank. The two open fermenters were set up at the far side of the room. The finishing tanks and a larger used bottling line went in on the first floor, and the basement was used for racking and storing kegs. Josh Ervine from Dock Street came on board to assist brewer Mike "Tuna" Martinovich. Eric Savage rented one of the stable buildings for his new business customizing Mini Coopers.

In April, Tom Kehoe, clad in lederhosen, rode a horse-drawn wagon loaded with beer to make the first delivery of Yards to ten accounts, culminating at the City Tavern. At the time, Yards was brewing the tavern's Founding Fathers series. Variations of these beers would later become packaged brands called Yards Ales of the Revolution. The new bottle line made packaging much more efficient. More fermenting and storage tanks were added, and production continued to increase.

Manayunk Brewery and Restaurant began contract brewing Krook's Mill Pale Ale at Yards in late 2000 and then got into bottling beer on its own. Jim Brennan hired Bill Young in 2002. Bill was a retiree who dreamed of becoming a brewer and has been there ever since. He's assisted every brewer who has come and gone there in the last decade. One of his creations has been Bill's Pils, which is distributed to outside accounts. Manayunk began relying more on guest beers to cater to the tastes of the huge crowds that flock there on weekends

and prefer mainstream beers. But the brewers continue to produce innovative quality products. In 2003, Larry Horwitz made a Stein Bier brewed with heated rocks and began doing more with barrel-aged beers. Chris Fiery replaced Larry a year later and popularized his California Dreamin' Double IPA. Doug Marchakitus succeeded Chris in 2010 and is currently head brewer.

Independence Brewpub had the advantage of a Center City location and proximity to Septa's regional rail terminal. Tim Roberts remained busy keeping the serving tanks full of house beers. Tim's Kölsch, brewed with 10 percent wheat malt and Tettnang hops, had been

Bill Young on the brewing platform at Manayunk Brewery and Restaurant. *Author's collection.*

a house favorite since the brewpub operated under the Dock Street name, but he was also known for his seasonal beers, including Scotch Ale, Imperial Stout, Pale Winter Warmer, Belgian Strong Ale, Summer Weizen and Oktoberfest. In August 2007, Roberts was in the middle of brewing when he was told to shut everything down. Employees were locked out, and the place was closed due to back rent amounting to nearly $1 million.

Craft Brewing Continues

Nodding Head Brewery and Restaurant

The Samuel Adams Brew House was reincarnated as the Nodding Head Brewpub by local restaurateur Tom Peters and his wife, Barbara Thomas,

and Curt Decker. They hired Brandon Greenwood to get the new brewery up and running. Additional space was secured to accommodate all grain brewing with a new seven-barrel JV Northwest system. The grand opening was held in February 2000. He stayed on as brewer for five years and gave Nodding Head the distinction of having more GABF awards than any brewery in the city.

Greenwood was given free rein, and he brewed a vast array of unique beers. In the fall of the first year, he began brewing a Harvest Ale with hops shipped overnight from the Pacific Northwest. Now a regular seasonal, Sled Wrecker was brewed with apples, raisins and spices. Bill Payer Ale has become a big seller, generously hopped with cascade hops. Ich Bin Ein Berliner Weiss began in an effort to popularize an endangered beer style that had been prolific in nineteenth-century Philadelphia. It became a regular seasonal served with Woodruff syrup. The house flagship has become Grog, a brown ale and GABF Gold Medal winner.

To accommodate its brisk trade, the Nodding Head acquired three tanks from Poor Henry's seven-barrel system in 2002. The additional space made it possible to supply a limited quantity of beer to outside accounts. Gordon Grubb became assistant brewer and took over as brewer when Brandon left. In 2005, Nodding Head took a gold medal at the GABF in the Specialty Honey Beer category for George's Fault, an Imperial Wit Beer. George Hummel, local homebrew shop owner and beer writer, supplied the recipe, which included Styrian Goldings, orange peels and coriander. He got to brew the beer with Greenwood and Grubb. The beer finished at 9 percent alcohol by volume. Gorden selected the name so that when patrons asked why they were so light-headed after one pint, the bartender could say, "It's George's Fault."

Triumph Brewery and Restaurant

The spring of 2007 saw the opening of Philadelphia's first brewpub that was part of a chain. New Jersey was slow to change its laws permitting brewpubs, and the company "Triumphed" when it made its appearance in Princeton in 1995. Eight years later, it opened a second location in New Hope. In Philadelphia, it is located on Chestnut below Second Street in Old City. At the time, Jay Misson was supervising brewing operations for the company and was charged with setting up the new brewery. Jay came to Triumph with a great deal of experience, not the least of which was a stint working for a brewery and malt house in Germany.

A Heady History of Brewing in the Cradle of Liberty

The old building on Chestnut Street required massive renovations, and the brewery portion was in a tight space. Patrick Jones worked with Jay on the project and became brewer. They installed a fifteen-barrel Newlands system with an oversized mash tun, giving them the opportunity to create some really big beers. The system also included six fermenters and a dozen serving tanks. With Jay's experience in Germany, lagers were the order of the day, and Triumph has become well known for its Pilsner beers, especially the unfiltered Keller Pils. Other regulars include Honey Wheat, Amber Ale and Bengal Gold IPA. The pub produces around one thousand barrels a year. Brendan Anderson currently brews at Triumph in Old City and New Hope.

Dock Street Brewing Company

In 2004, Rose Certo had Bill Moeller tweak the recipe for Dock Street Bohemian Pilsner and brought it back as a contract brand made in Utica. Rose and her husband, Jeffrey Ware, wanted to start another brewery and began looking for a location. They found an old firehouse on Fiftieth Street just below Baltimore Avenue in West Philadelphia that had been used as a farmers market. By the fall of 2006, Dock Street got the necessary zoning variance to open a brewery and restaurant there. The space was smaller than the original location, and the concept was to serve gourmet pizza and a full range of beer styles for both the restaurant as well as outside accounts. It was outfitted with a ten-barrel pub brewing system, four fermenters and six serving tanks.

The new Dock Street Brewery and Restaurant opened in August 2007. All the beers are unfiltered, and some of the regulars in its lineup are: White Ale, Gold Stock American Pale Ale, a Rye IPA with Simcoe and Amarillo hops and an Imperial Oatmeal Stout. Dock Street has continued to be creative as far as brewing unique styles. Sudan Grass is an African-inspired gluten-free beer made with sorghum. It is flavored with buckwheat toasted in the pizza oven and brewed with Centennial hops. Prisoner of Hell is a strong Belgian-inspired pale ale aged with chili peppers. And with a nod to a tavern in the neighborhood that gave Dock Street its name, they brew Man Full of Trouble Porter.

Philadelphia Brewing Company

Around the same time that Independence Brewpub closed, a surprising announcement surfaced. Yards Brewing Company was moving, but a new brewery called the Philadelphia Brewing Company would remain in the old Weisbrod and Hess building. Tom Kehoe wanted Yards to grow and said the

This decorated storage tank draws attention during Saturday tours at Philadelphia Brewing Company. *Author's collection.*

company needed a larger facility. The Bartons were invested in the building and wanted to continue to make improvements and continue brewing there. The answer was for Tom to retain the Yards name and brands and for Bill and Nancy to form a new company with the property and equipment. They went their separate ways at the end of 2007.

Philadelphia Brewing Company got underway in February with its new lineup of beers: Kenzinger Beer, a pils/kölsch clone; Newbold IPA, loaded with Amarillo hops; a Belgian-style wit called Walt Wit after Camden's best-known poet; and Rowhouse Red, a complex ale brewed with American and European malts and rye and fermented with Belgian yeast.

They have begun offering a number of seasonal brands. The first was introduced in 2008. Fleur de Lehigh is named in honor of Shibe Park on Lehigh Avenue where the Phillies and Athletics used to play ball. It is an unfiltered golden ale brewed with lemon grass, rhubarb root, cardamom seed, rose hips and ginger. It was so well received that they began bottling it. Next came Joe, a coffee porter, brewed with Munich malt and fair-trade coffee in season, which started as draught-only and then made it into bottles. At present, these two seasonals are available in twelve-ounce bottles. Other specialty products are available in kegs and twenty-two-ounce bottles when in season.

Nancy Barton is active in the East Kensington Neighbors Association and hosts its monthly meetings. Philadelphia Brewing is involved with a number of organizations that promote sustainability, including Greengrow Farms, Fair Food, Farm to City, Philly Tree People and Philadelphia Orchards. They also participate in the Kensington Kinetic Sculpture Derby, host barbeques following the semiannual Frankford Avenue Cleanup days and supply beer for Northern Liberty Neighbors' Liberty Fests.

Yards Brewing Company

Tom Kehoe restructured Yards Brewing Company, retaining a majority interest. It took the better part of a year for Yards to resume brewing. To maintain a presence in the market, Yards contract brewed its India Pale Ale through the Lion, Inc. The company's fourth location is in an industrial building on the east side of Delaware Avenue below Poplar.

It obtained a used 50-barrel JV Northwest brew house and started out with two 200-barrel fermenters and four 100-barrel tanks providing for a 16,000-barrel-a-year capacity. The brewery has since expanded to include seven 200-barrel fermenters and two 200-barrel bright tanks. Production

the first year was 7,000 barrels and had tripled by 2011. Brawler, a "pugilist ale," was reintroduced and has become a top seller. Bottled beer accounts for around 60 percent of sales. In the tasting room, patrons can look through a glass partition to see the day-to-day operations of the plant. To the right is the large platform that holds the four-vessel brewing system, and to the left is "Yards One," the original 3.5-barrel system that has been resurrected and used to create specialty brews for the house or outside accounts. The company holds the distinction of being Pennsylvania's first wind-powered brewery through its purchase of wind-generated electricity.

Earth Bread and Brewery

Tom Baker left a career in computers to pursue his dream of brewing. In 1999, he and his wife, Peggy Zwerver, started a small production brewery called Heavyweight Brewing Company in Ocean Township, New Jersey. As the name implies, the brewery specialized in making big beers, which immediately became cult favorites among aficionados. After about seven years, they were ready for a change and shut the brewery down. Tom announced he was looking for a place to open a brewpub and wanted to combine brewing beer and baking bread. After an extended search, they found a location in Philadelphia's Mount Airy neighborhood on Germantown Avenue above Mount Pleasant Avenue.

Earth Bread and Brewery opened in the fall of 2008. The brewery and restaurant was set up with Tom's original ten-barrel DME system, and he constructed a wood-fired Neapolitan Pompeii oven to bake flatbreads. Tom and Peggy wanted a sustainable business with an emphasis on locally produced ingredients and being a part of the community. Their flatbreads are made with organically grown wheat ground at the nation's oldest continuously operated mill in Lebanon County. The décor consists entirely of recycled materials. The exterior of the building displays a mural entitled "Walking the Wissahickon," sponsored by the city's Mural Arts Program.

Tom began brewing session beers and brought in a rotating selection of local craft beers. The opening lineup included a mild ale called Love Your Mother, a Belgian-style dubbel called Lil' Pylon, a smoked wheat ale called Terra Fume and Sedgwick Pale Ale, made with lemon verbena and hops grown by a local resident on Sedgwick Avenue. Tom has brewed an esoteric mix of beer styles, some of which are fermented with bread yeast. He has even recreated an ancient herbal style known as Gruit, including one made

with Chinese Lapsang tea. Tom invited members of the homebrew club at Clivedon, a historic site in nearby Germantown, to brew a beer based on those brewed by Belgian's Rochefort Trappist monastery. The result was Cuvee de Clivedon, a 9 percent ale served at a fundraiser for the site held early in 2011.

Iron Hill Brewery and Restaurant, Chestnut Hill

The latest addition to Philadelphia's brewing community was the opening of Iron Hill Brewery and Restaurant in Chestnut Hill in January 2012. It is the ninth location for this highly successful Delaware-based chain of brewpubs, established in 1996 by Kevin Finn, Kevin Davies and Mark Edelson. They were on hand at the "First Pour" event, along with city council members Bill Green and Cindy Bass.

Paul Rutherford has been tapped as brewer. He set up Iron Hill's brewery in Lancaster and welcomed the opportunity to oversee the installation of this location, which has been outfitted with a brand new 10-barrel Specific Mechanical system. Included in the system is a "hop back" capable of holding over twenty pounds of whole hops that can be used to enhance both the hop flavor and "nose" of the beer. Paul used the hop back to full advantage with his first batch of Kamikaze IPA, which was brewed with copious quantities of Columbus, Chinook, Centennial and Sorachi hops. Production is anticipated to be around 1,200 barrels a year.

What the Future Holds

Currently craft brewing is the only segment of the market that is growing. It took many years for it to occupy even 1 percent of the market but today is in the neighborhood of 5 percent. Around half of the top dozen or so breweries in the country began as microbrewers or contract brands. And the vast majority of the top fifty are craft brewers. There are more breweries in the country today than there were at the turn of the last century.

Manayunk Brewery and Restaurant has been the most successful brewpub in terms of longevity. As a brand, Dock Street has been around longer than any other local beer or brewery. The Nodding Head Brewery has been in business for over a decade. It replaced the city's first brewpub,

which had been at that location since 1989. The success of these companies and the fact that new brewpubs have opened suggests that Philadelphia's brewpub culture is sustainable.

Philadelphia's production breweries fall into two categories. Philadelphia Brewing Company produced around twelve thousand barrels in 2011, making it a microbrewery, while Yards produced around twenty-one thousand barrels, making it a regional craft brewery. Yards is the city's oldest production brewery, and its recent growth has exceeded the company's expectations. Both have become central to the city's craft brew scene and, by all accounts, can be expected to continue successfully.

Looking back on over three centuries of brewing in Philadelphia should caution anyone against making predictions. Changes in tastes, technology, the economy, the law, immigration and even the weather can radically alter the equation. Today, breweries large and small throughout the industry are focusing on sustainability. Philadelphia's production breweries are conscious of the importance of being environmentally friendly if for no other reason than that it can be profitable to do so in the long term. With the continued support of customers in both the local and regional markets, the prospects appear positive for the city's brewing tradition to continue to have a long and productive lifespan.

Bibliography

Arnold, John P., and Frank Penman. *History of the Brewing Industry and Brewing Science in America.* Chicago, 1933. Reprint, Cleveland, OH: BeerBooks. com, 2006.

"Associations of Mifflin Mansion." Newspaper clipping in Castner Scrapbooks 1845–1962, Vol. 27, p. 67. Free Library of Philadelphia.

Baron, Stanley. *Brewed in America.* Boston/Toronto: Little, Brown, 1962.

Belcher, R.D. "200 Years of Anglo-American Brewing." *MBAA Technical Quarterly*, July/August/September 1977.

Bergner & Engel Brewing Company. "Modern Brewing of an Ancient Beverage." Booklet in personal collection of Eble family, 1906.

Blodget, Lorin. *Census of Manufactures of Philadelphia.* Philadelphia: Dickson & Gilling, 1883.

Brewing in Philadelphia. Supplement to the *Western Brewer.* Chicago, January 1881.

Broderick, Harold M., ed. *The Practical Brewer: A Manual for the Brewing Industry.* 2nd ed. Madison, WI: Master Brewers Association of the Americas, 1977.

Bryson, Lew. *Pennsylvania Breweries.* Mechanicsburg, PA: Stackpole Books, 1998.

C. Schmidt & Sons Brewing Company. *The Case.* House organ, 1946–1970.

Claussen, W.E. *Wyck: The Story of an Historic House 1690–1970.* Philadelphia: M.T. Haines, 1970.

Cotter, John L, Daniel G. Roberts and Michael Parrington. *Buried Past: An Archeological History of Philadelphia.* Philadelphia: University of Pennsylvania Press, 1992.

Curtin, Jack. "Homeboy Brews." *Philadelphia Weekly*, July 12, 1995.

————. "Stockbrokers Gone Wild." *American Brewer*, August 2006.

Edwards, Richard. *Industries of Philadelphia*. Philadelphia, 1879

Francis Perot's Sons Malting Company of Philadelphia. *The Oldest Business House in America Established in 1687*. Philadelphia: self-published, 1907.

Freedley, Edwin. *Philadelphia and its Manufacturers*. Philadelphia: Edward Young Publisher, 1859.

Graham, Robert E. "Inns and Taverns of Colonial Philadelphia." Card file on Early Philadelphia Taverns. American Philosophical Society, Philadelphia, 1950–53.

Homans, James E., ed. *The Cyclopedia of American Biography: New Enlarged Edition of Appleton's Cyclopaedia of American Biography Volume VIII*. New York: Press Association Compilers, Inc., 1918.

Illustrated Philadelphia. New York: American Publishing and Engraving Co., 1891.

Independence Brewing Company. *Declaration* (Summer 1995–Spring 1998).

John F. Betz & Son, Ltd. Price List and Catalog. Booklet in Handy Collection.

Johnson, Donald F. "Brewing Capital: Making and Marketing Beer in the Delaware Valley, 1760–1800." Master's thesis, University of Delaware, 2009.

Koenig, Richard. "Embattled Brewer—Philadelphia Beer King Fights Tax Conviction, Allegations of Mob Ties." *Wall Street Journal*, September 23, 1983.

Lindstrom, Diane. *Economic Development in the Philadelphia Region, 1810–1850*. New York: Columbia University Press, 1978.

Macfarlane, John J. *Manufacturing in Philadelphia 1683–1912*. Philadelphia: Philadelphia Commercial Museum, 1912.

Manufactories and Manufacturers of Pennsylvania of the Nineteenth Century. Philadelphia: Galaxy Publishing, 1875.

Mathias, Peter. "Industrial Revolution in Brewing." *Explorations in Entrepreneurial History* 5, no. 4 (May 15, 1953): 208–24.

McNealy, Terry A. "Early Brewing and Distilling on the Delaware." *Mercer Mosaic*, July/August 1986.

Monahan, M., ed. *A Textbook of True Temperance*. New York: United States Brewers Association, 1909.

Nash, Gary B. *Forging Freedom: The Formation of Philadelphia's Black Community*. Cambridge, MA: Harvard University Press, 1988.

O'Bannon, Patrick. "Inconsiderable Progress, Commercial Brewing in Philadelphia Before 1840." *Early American Technology: Making and Doing Things from the Colonial Era to 1850*. Edited by Judith A. McGaw. Chapel Hill and London: University of North Carolina Press, 1994.

Oberholtzer, E.P. *Philadelphia History of the City and Its People: A Record of 225 Years*. Vol. 3. Philadelphia: S.J. Clarke, 1908.

One Hundred Years of Brewing. Supplement to the *Western Brewer*. Chicago and New York: H.S. Rich, 1903. Reprint, New York: Arno Press, 1974.

Perot Family Papers, 1705–1956. Series 1. Perot Malting Co. 1818–1953 (box 2, vol. 89–90). Historical Society of Pennsylvania, Philadelphia.

Philadelphia: A History of the City and Its People: A Record of 225 Years. Vol. 4. Philadelphia: S.J. Clarke, 1911.

Roach, Hannah Benner. "A Philadelphia Business Directory for 1690." *Pennsylvania Genealogical Magazine* 23 (1963–64): 95–129.

Robson, Charles. *The Manufactories and Manufacturers of Pennsylvania in the Nineteenth Century*. Philadelphia, 1875.

Salem, F.W. *Beer, Its History and Its Economic Value as a National Beverage*. Hartford, CT: F.W. Salem, 1880.

Scharf, J. Thomas, and Thompson Wescott. *History of Philadelphia*. Philadelphia: L.H. Everts, 1884.

Sexton, Sharon. "How the Feds Nailed Billy Pflaumer." *Inquirer*, November 23, 1986.

Thomann, Galus. *American Beer: Glimpses of Its History and Description of Manufacturing*. New York: United States Brewers Association, 1909.

Thompson, Peter. "A Social History of Philadelphia's Taverns 1683–1800." PhD diss., University of Pennsylvania, 1989.

Trautmann, Frederick. "Pennsylvania through a German's Eyes: The Travels of Ludwig Gall, 1819–1820." *Pennsylvania Magazine of History and Biography* vol. CV (1981): 35–65.

Twitt's Directory of Prominent Businessmen. Philadelphia, 1857.

United States Brewers Association Souvenir Album. New York: United States Brewers Association, 1896.

Wahl, Robert, and Max Henius. *American Handy Book of the Brewing, Malting and Auxiliary Trades*. Chicago: Wahl Henius Institute, 1901.

Walker, Francis A., ed. *International Exhibition, 1876*. Vol. 4, Groups III–VII. Reports and Awards Series, Washington D.C.: U.S. Government Printing Office, 1880.

Western Brewer and Journal of the Barley Malt and Hop Trades. Chicago, 1876–1933.

Other Resources

American Brewer, April 1933–December 1969. Free Library of Philadelphia.

Evening Bulletin. Microfilm. Free Library of Philadelphia.

Pennsylvania Gazette. Free Library of Philadelphia.

Philadelphia Contributionship Surveys. Insurance surveys. American Philosophical Society, Philadelphia.

Philadelphia Inquirer. Microfilm. Free Library of Philadelphia.

Public Ledger. Microfilm. Free Library of Philadelphia.

Wagner, Rich, ed. *Craft Brewing in Philadelphia 1985–2005.* Hatboro, PA: Soy World, 2005. E-book edition.

Wagner, Rich, ed. *Philadelphia Breweries During Prohibition.* Hatboro, PA: Soy World, 2006. E-book edition.

Index

INDEX

T

Talmon, Lewis (brewery and distillery, Brewerytown) 43
technological innovations 27, 40, 101
 architectural 101
 electricity 71, 82
 electricity, wind-generated 142
 high-pressure mashing 83
 hydrometer 24, 29
 mashing machine 27
 palletization system 113
 reduction in beer storage time 101
 stationary steam engine 28
 thermometer 24

U

United States Brewers Association 41, 89

V

Vollmer and Born Brewery, Brewerytown 50

W

Wagner, John 36
Walter and Franz Brewery, Brewerytown 51
weiss beer, American 53, 66, 67, 70, 79, 80
weiss beer, Berliner 69, 138
Western Brewer 41, 75, 83
wheat beer 126, 139, 142
Whitetail Brewing Company, York, PA 130

Y

yeast 24
 ale 35
 Belgian 125, 141
 bread 142
 early research 35
 handling 23
 lager beer 35, 36, 38

pitching 23, 29
Prohibition 90
pure culture 40, 67, 83
sedimentation 101
Yuengling, D.G. 76

About the Author

Beginning in 1980, when he set out to visit all nine of Pennsylvania's breweries that were still in business, the author's path seems to have been one of total immersion. Traveling throughout the state, he began to notice the hulking remains of long-gone breweries dotting the landscape and set out to create a photographic inventory of all standing brewery buildings in Pennsylvania. At the time this book was written, he had visited well over four hundred sites and found something to photograph at nearly half of them.

Photo by Anna Wagner.

By 1983, Rich tried his hand at home-brewing and, before long, had set up a gas-fired system in a friend's basement, utilizing an old beer keg as a kettle. In 1990, he interpreted colonial brewing using replicas of seventeenth-century equipment at Pennsbury Manor, a reconstruction of William Penn's country estate on the Delaware River. Within three years, he had worked with a cooper over an eight-month period to manufacture his own system, starting with two cypress logs. That year, he went on a cross-country journey to demonstrate brewing techniques of antiquity. He was a high school science teacher who traveled extensively during the summers, visiting national parks

and geologic sites throughout the nation and, during the 1980s, as the craft brewing renaissance began to take hold, found many craft breweries to visit as well. To date, he has visited well over six hundred breweries throughout the United States and Canada.

His research into Pennsylvania breweries continued, becoming deeper and more serious as he visited libraries and historical societies and amassed a great deal of information. Rich became involved with breweriana collectors and joined some of their organizations. He also became connected to the Society of Industrial Archeology. Rich developed tours of breweries past and present for Philadelphia, Pittsburgh, the Lehigh Valley, Wilkes-Barre/ Scranton and south-central Pennsylvania. Some of these were sponsored by breweriana clubs and others by historical societies and other organizations. He published guidebooks to go with each tour, and he also issued a number of posters.

Finally, the inevitable came when his avocation overtook his vocation. Rich took very early retirement from his teaching career in order to participate in the emerging craft brewing industry. He attended the Siebel Institute of Technology in Chicago, where he received a diploma in brewing technology and spent seven years working in Philadelphia's craft breweries. He has spent a decade as an officer of District Philadelphia, Master Brewers Association of the Americas, most of that time as secretary and membership chair.

He currently spends his time researching and writing about Pennsylvania breweries and brewing techniques of antiquity. He is a public speaker and demonstrates colonial brewing. For more information, visit his website: http://pabreweryhistorians.tripod.com.

Visit us at
www.historypress.net